CHINA OBSCURA

CHINA OBSCURA

CHINA OBSCURA

photographs by MARK LEONG

foreword by YANG LIAN

afterword by PETER HESSLER

CHRONICLE BOOKS

SAN FRANCISCO

NOTE: Chinese names in the book are written in standard *pinyin* romanization,
except for those connected with my relatives (in which case family spellings are
used) and a few well-known names such as Yangtze and mah-jongg.

Mark Leong is represented by Redux Pictures.

LIBRARY OF CONGRESS CATALOGING-IN-PUBLICATION DATA:
LEONG, MARK.
CHINA OBSCURA : [MARK LEONG] ; PHOTOGRAPHS BY MARK LEONG ;
FOREWORD BY YANG LIAN ; AFTERWORD BY PETER HESSLER.
 P. CM.
ISBN 0-8118-4461-7
1. CHINA–DESCRIPTION AND TRAVEL–PICTORIAL WORKS. I. TITLE.
DS712.L47 2004
951.05'9'0222–DC22
 2003027895

MANUFACTURED IN SINGAPORE
BOOK AND COVER DESIGN BY SARA SCHNEIDER

DISTRIBUTED IN CANADA BY RAINCOAST BOOKS
9050 SHAUGHNESSY STREET
VANCOUVER, BRITISH COLUMBIA V6P 6E5

10 9 8 7 6 5 4 3 2 1

CHRONICLE BOOKS LLC
85 SECOND STREET
SAN FRANCISCO, CALIFORNIA 94105
WWW.CHRONICLEBOOKS.COM

for my father

RAYMOND LEONG

FOREWORD: YANG LIAN

FOREWORD: YANG LIAN

Perhaps it is only when you know a place so well that it can seem so strange.

I grew up and lived in China until the age of 33. After 1989, I experienced a typical Chinese destiny of exile, living in more than twenty countries. Now I hold a New Zealand passport. My face is obviously Chinese, but China has become my personal foreign country. I write my poetry in Chinese, but the language has become my own foreign mother tongue. There is no longer any question of going home. Now even when I set foot on Chinese soil, it is still another kind of leaving.

Mark Leong's photographs are also about homecoming as departure. For him, the native land of his ancestors is his own foreign country. His pictures bring to mind an image from a journey I made not long ago: I am standing beneath the frosty skies of northern China gazing upon an expanse of broken walls and piles of earth, buried speechless and silent beneath a covering of white snow and withered grass. This was Yellow Earth South Inn Village where I spent three harsh years at the end of the Cultural Revolution in the 1970s. These fields, where "class enemies" were once buried alive, nurtured generations of people, but also held back generations of people, detaining them as if in a prison. Here in the old alleys, beneath each crooked gatehouse, behind every earthen wall, were concealed so many stories; the stories

we gave to them every day, each person listening to the others, each person overheard by others. . . .

Yet now I stare at this place in a mixture of shock and dumb incomprehension; am I drunk? The village is no longer there. It has vanished so completely that not even its name remains on the map. Soon a vast swath of concrete buildings will rise up from these fields, like a crop that can never be harvested. The future installments of those stories will take place in these hard concrete stairwells. The stories of the past now exist as ghostly spirits, formless in the air, perceived only by the eyes of memory.

Mark Leong has returned to China at a historic moment where an ancient way of life has met China's newborn future. His photographs layer the new upon the old, images permeating each other, as if printed from piles of negatives stuck together. These pictures—so many ordinary details of ordinary people's lives—remind me that China will never lack the poetry of beauty and pain. I see not just our past, but also a kind of beginning—thrilling yet filled with misgivings.

Both familiar and alien, these photographs are the hundreds of thousands of questions we ask ourselves every day.

Translated from the Chinese by Duncan Hewitt

INTRODUCTION

My mother never saw her ancestral home of Soon Wall Village on Guangdong's Pearl River Delta. A second-generation American, born in Chicago in 1938, she never visited China. In her 1956 high school class photo—the year she won a Betty Crocker Homemaker of Tomorrow Award—she is one of two Asian faces among fifty-seven students. She followed the Cubs and taught lunchtime arts and crafts at my elementary school. May Fong Leong died of cancer in 1981, having never once left the United States.

Her father came to America in 1923. His English name was Henry Fong, his Chinese name was Fong Quong Zon, and the fake immigration papers he bought said "Fong Wing Ak," but we grandchildren always called him Gon Gon. Growing up in Sunnyvale, California, an hour south of San Francisco, I knew when Gon Gon was about to show up because my mother would buy a pot of rice whiskey, half a dozen grapefruit, and a box of toothpicks for him.

He would arrive at the airport, a small, retired laundryman whose white shirt and dark suit matched his white hair and black eyebrows, carrying parcels wrapped in twine with little wooden handles and shopping bags full of musty, herbal, fishy, fungal *Chinese*-smelling stuff. When he didn't shave for a few days, I thought he looked like Marlin Perkins from the TV show *Mutual of Omaha's Wild Kingdom*. Mom would set him up in my room and I would sleep on the extra mattress on the floor. Gon Gon was a big snorer.

My favorite part of my grandfather's visits was when he would walk my sisters and me to the Toys "R" Us. Maybe Gon Gon didn't think of it this way, but I saw the toy store as a payoff for the dreaded Sunday trip up to San Francisco's Chinatown.

For much of my childhood I thought San Francisco *was* Chinatown, because that was the only place we ever went in the city. Dressed in our uncomfortable church clothes, we would trudge up and down the hilly streets while Gon Gon popped in and out of stores hunting for a specific type of dried herb or root. Everything always seemed to be sweating or dripping in Chinatown—the crowds of shoppers, buckets of squid, boxes of pears, piles of garbage, even racks of plastic souvenirs made in Hong Kong.

Afterward, we would visit relatives who we would see only when Gon Gon was in town. These were the relatives whose houses smelled like Gon Gon's shopping bags; their walls were decorated with Chinese calendar girls, and their candy dishes were filled with salty gray plums. My mother was the only one of Gon Gon's eight children to marry an ethnic Chinese (my father is a fourth-generation American), but since my parents spoke different dialects, my sisters and I spoke only English at home. The relatives would cluck at us in Taishan dialect, and Mom would explain, "They're asking why you don't smile."

Relatives would arrive all afternoon to see Gon Gon, chattering over endless cups of tea. The hours would creep by, and I would flip through a pile of Hong Kong comic books that I couldn't read. Finally, we would all go out for dinner, a big meal of exotic dishes, shark fins and sea cucumbers, with fried noodles for the kids.

At the end of the evening when we said our good-byes, Gon Gon and rest of the older relatives would pass out red envelopes to all of the children. My mother had once read us a story about bad kids who ripped the money out of their red envelopes right in front of the people who had given them, so I knew not to look right away to see how much was inside. But I could feel if it was a quarter or a dime, or something good, like paper money or a heavy silver dollar. Squeezing it in my hand, I would fall asleep in the station wagon on the way back to Sunnyvale.

* * *

On June 5, 1989, the day after the crackdown on Tiananmen Square, I took the express train three hours across the border from Hong Kong to Guangzhou, in mainland China. This was the first time I had ever been to China. I was traveling on a yearlong art fellowship to document Chinese daily life. My college honors thesis the previous year had been a photographic study of American Chinatowns, so taking pictures in China itself was the obvious next step. But, easing out of a Sunnyvale childhood spent trying to ignore my ethnicity, I did not expect an instant motherland soul connection the moment I stepped foot on Chinese soil. Neither did I expect to enter the country at such an ominous time, but I had already bought my train ticket before the troops began to move on the square, the night of June 3, so I decided to go anyway. Guangzhou is more than a thousand miles south of Beijing, and I figured I could just hop back over to Hong Kong if there was any danger. Still, I was the only foreign passenger on a mostly empty train.

In Guangzhou, I went to a university where a friend was teaching English and had arranged for me to stay in the "Foreign Experts Building." The students there had seen the previous day's events in Beijing on television broadcasts from Hong Kong. Already, traditional white floral memorial wreaths dedicated to the fallen demonstrators covered the outdoor stage on the university soccer field. That night the students gathered in the darkness around the wreaths to decide what to do. Rumor was that army tanks and troops were already entering Guangzhou to establish martial law, occupying universities and other centers of prodemocracy activity. The students decided it would be best for

everybody to go home to their families and lie low rather than face the government forces. The next day, the campus was empty. Most of the students left without taking their final exams.

The tanks never appeared. That summer, I went to the northeastern city of Dalian to study Mandarin. I also visited Shanghai and Beijing, but didn't take many photographs—the big cities seemed paranoid and depressing. In Beijing, helmeted soldiers were everywhere, standing under umbrellas on the streets. Locals I met whispered that I should be careful about taking my camera out of my bag.

That fall I returned to Guangzhou, where the new fall university term started as usual, with full enrollment. The Communist Party restored two classes to the mandatory curriculum for college freshmen. One, a political education class, reiterated the basic tenets of socialism. The other, a military training course, required teenaged boys and girls in matching blue sweatsuits to march around the campus with rifles and bayonets, throw live hand grenades, and shoot human-shaped paper targets.

* * *

Soon Wall Village was less than two hours away from Guangzhou by bus, but it was already the end of winter by the time I made it out there. I'd been traveling in the countryside, where it was much more relaxed than in the cities, and I'd begun to feel more comfortable taking pictures.

My uncle Louie from Chicago had sent an introduction letter ahead of me, so when I arrived at Soon Wall's small cluster of stone houses and said that I was the grandson of Fong Quong Zon, the villagers welcomed me as if I were born there. Nearly everyone in the village was named Fong. I couldn't understand their Taishan dialect, but my basic Mandarin worked well enough with the younger people.

Fong Shee Min, a distant cousin, led me up a narrow lane as he carried a bowl of rice and vegetables to another stone house whose front wall had crumbled almost completely away. He yelled toward the dark silence in the back of the building. Rustling sounds came from a shadowy loft rising above the back wall. A few moments later, a pair of skinny, bare legs emerged, pale against the darkness. A figure clambered gnome-like down the ladder.

At eighty-three years old, Gon Gon's cousin Fong Ny Geung was my oldest living relative left in China. Deep furrows stitched ancient flesh to his skull, a grizzled chin sprouted loose gray wisps. His hair was white and his eyebrows were mostly black, and it struck me that he was a crumbled version of Gon Gon.

Like most of the young men in Soon Wall in the 1930s, he was in line to follow an immigrant chain from the village to the United States that had begun at the end of the nineteenth century, as sojourning laborers put up permanent residence in America. But when his turn came to follow Gon Gon to the United States, the Japanese invaded China. Then came the Communist Liberation, followed by the Great Leap Forward, and the Cultural Revolution. Under Mao Zedong, China closed itself down to the world outside, and by the time it reopened under Deng Xiaoping in the 1980s, Fong Ny Geung had missed his chance. He was too old to go anywhere.

I looked at his face and I wondered who I would have been had my grandfather missed his chance, too, and not emigrated to America so long ago.

* * *

Fifteen years since I first came to this country, my China is more of a learned territory than a natural homeland. Slowly I try to gather clues, from the morning cry of the rice seller and the tangle of arms thrust toward the ticket window, the fumes of a coal-burning stove, and an overnight journey on a bus full of frogs and songbirds. The herbal doctor feels my pulse and examines my tongue; I bargain with the knife sharpener and test my lightbulbs before buying.

Meanwhile, all around this dream-simple sense of passing days, buildings, neighborhoods, and entire industries are falling and rising with sudden swiftness. I spend the morning writing at home, and then go out for lunch to discover rubble where my favorite noodle shop stood just yesterday. In the alleyway, the neighbors are poring over developers' plans posted on the lamp-posts—apparently, my own courtyard house (where a merchant's mistress lived during the Qing Dynasty and the men's table tennis champion played with the local kids after Liberation) is also scheduled to be leveled soon.

Hungry, I pedal my bicycle east on the Avenue of Eternal Peace. To the left, migrant workers jackhammer the highway twenty-four hours a day but never wide enough for the creeping glut of traffic. On the right, roadside vendors hawk flyswatters, celebrity magazines, pirated DVDs, underwear, Internet cards, binoculars, shoelaces, ear-cleaning spoons, mobile phone holsters, and puppies. Noodleless, I buy my lunch at an international fast-food outlet.

Photography gives me the patience to see through the relentless flurry of activity into the pockets of quiet, gaining understanding—or at least contact—that I otherwise might not have. As this most massive of mass societies surges and swells, I try to zero in on individuals, seeking something in common. If it were not for my desire to take pictures, perhaps I never would have come to China. I am beginning to suspect that I may never find my inner Chinaman. But I linger, and wander, a blinking shutter negotiating the tension between motion and stillness.

— M A R K L E O N G
Beijing

PLATES

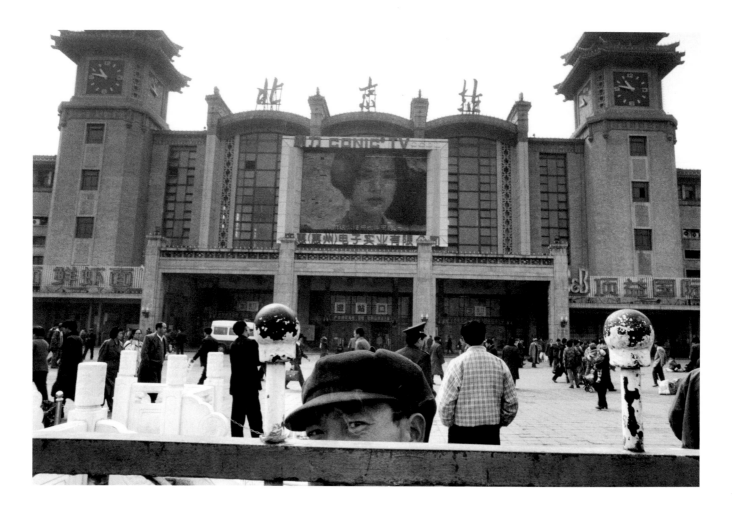

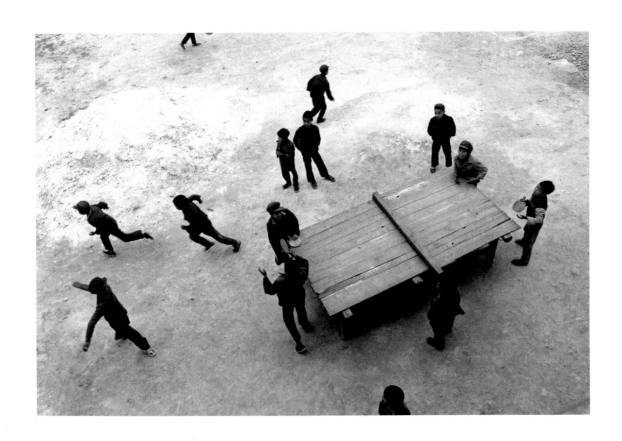

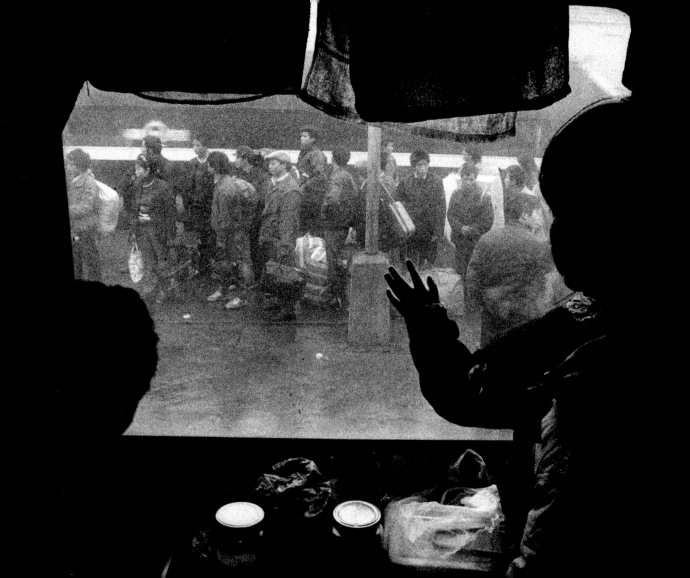

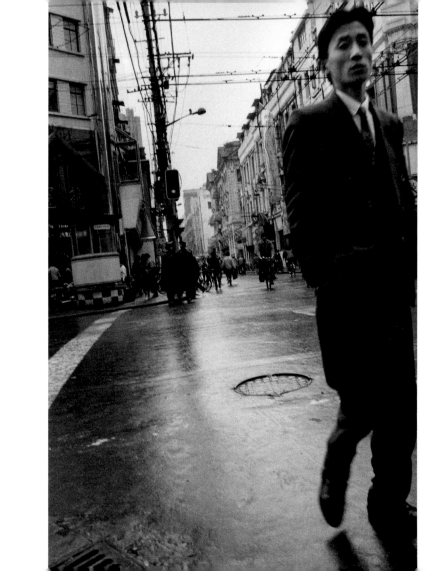

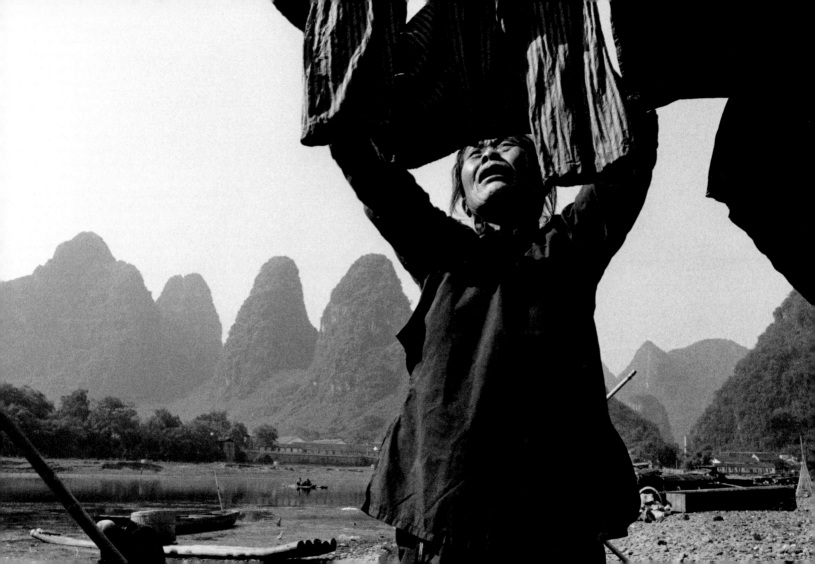

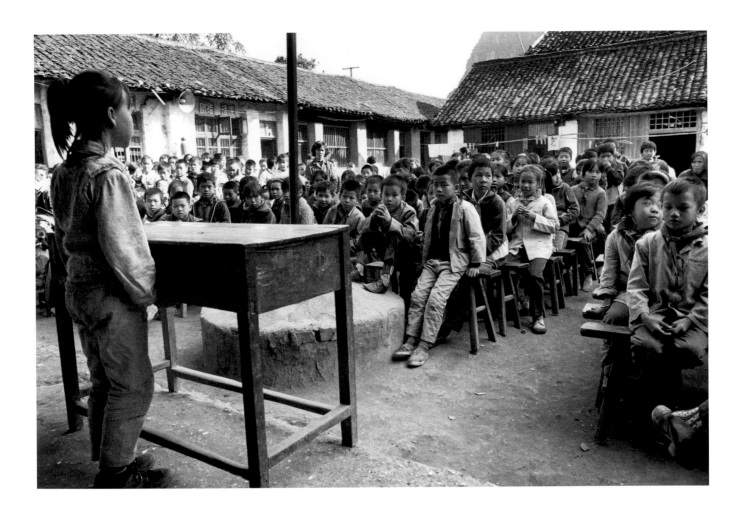

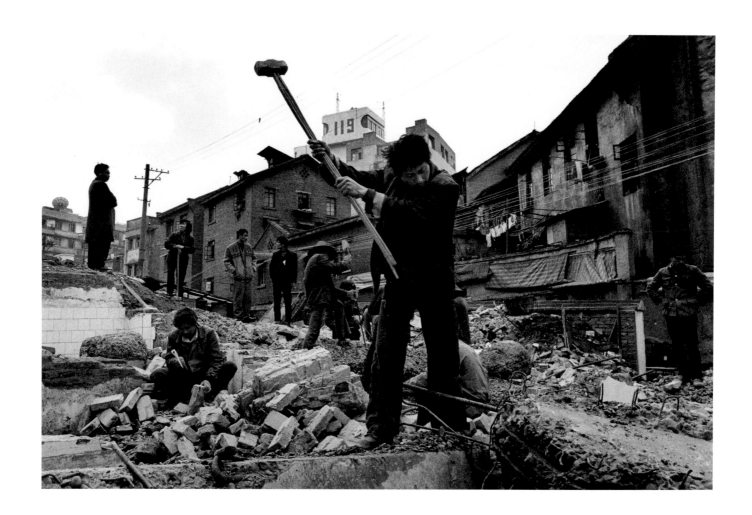

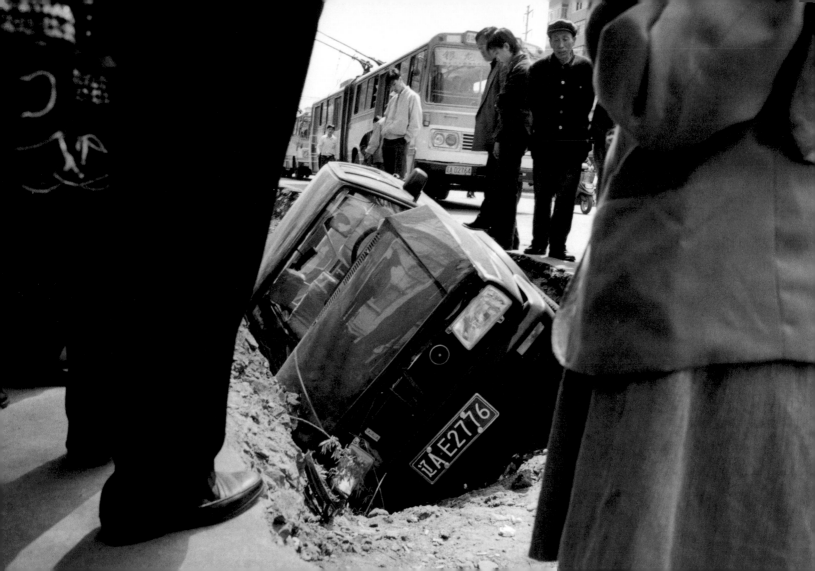

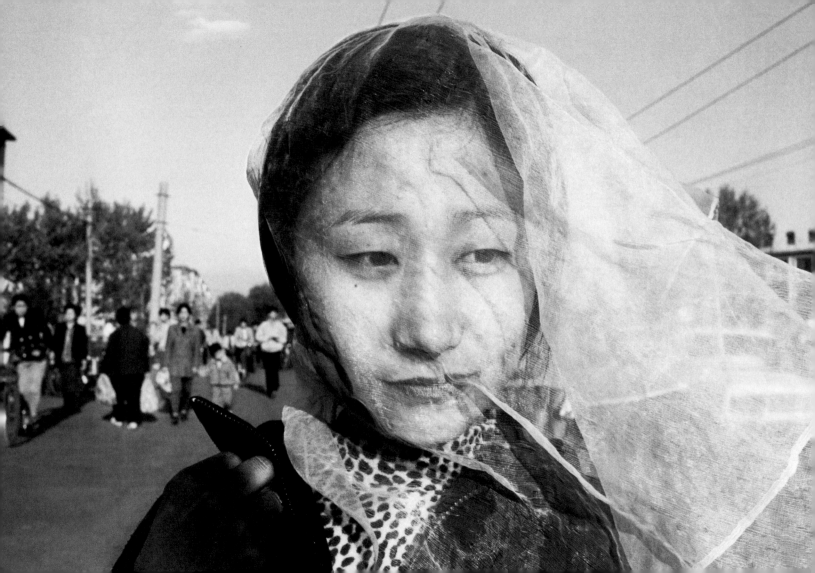

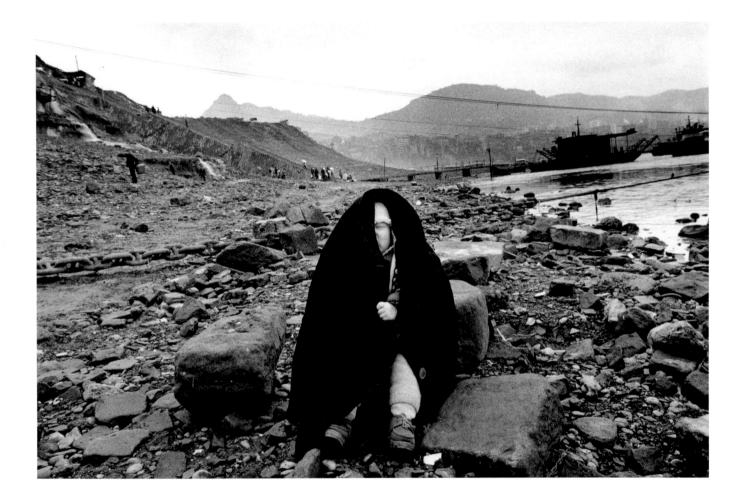

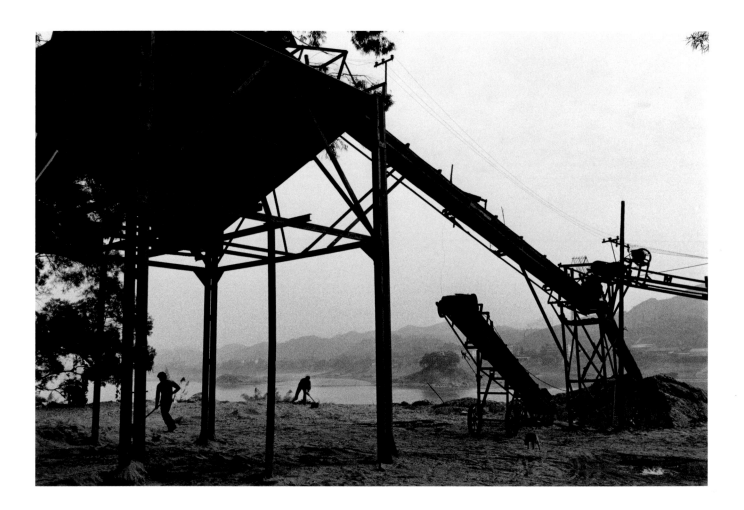

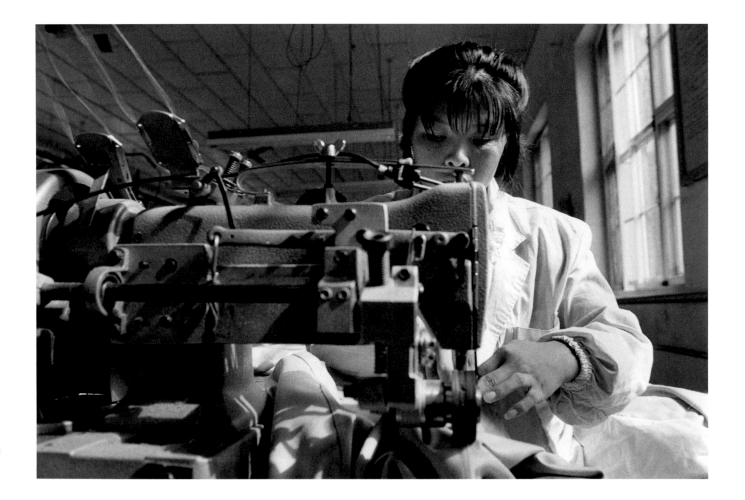

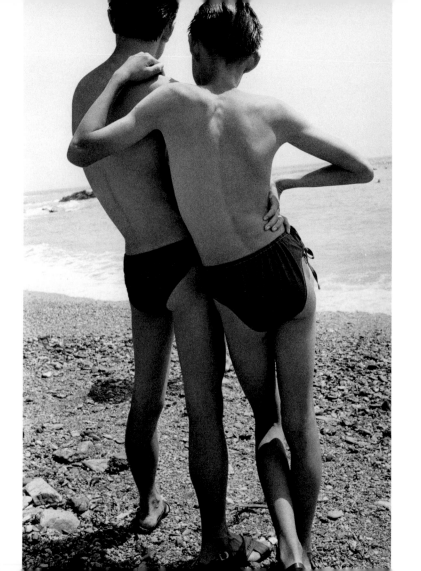

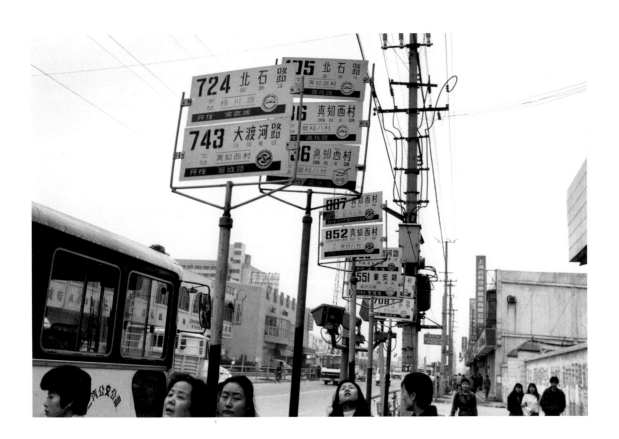

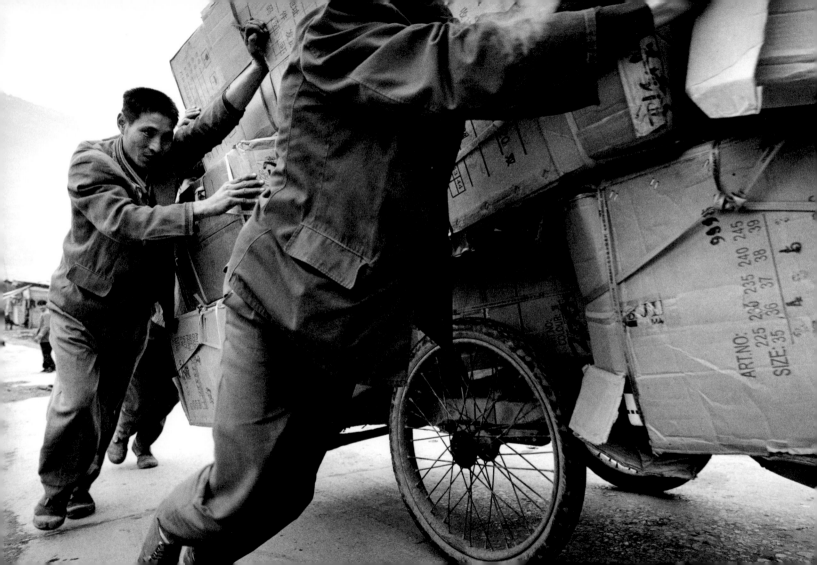

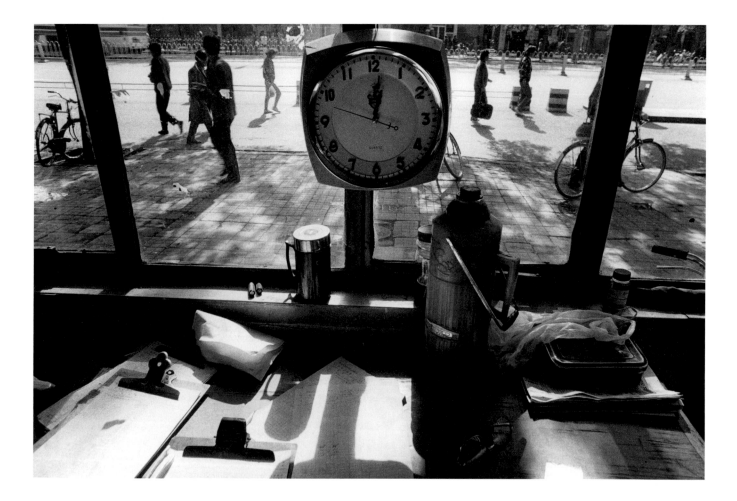

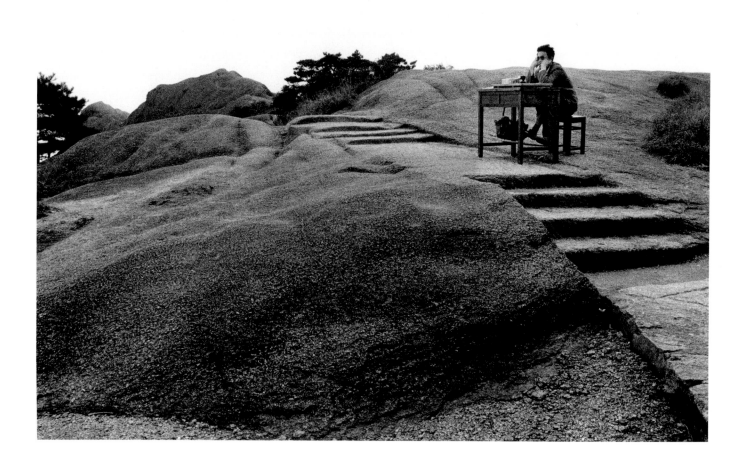

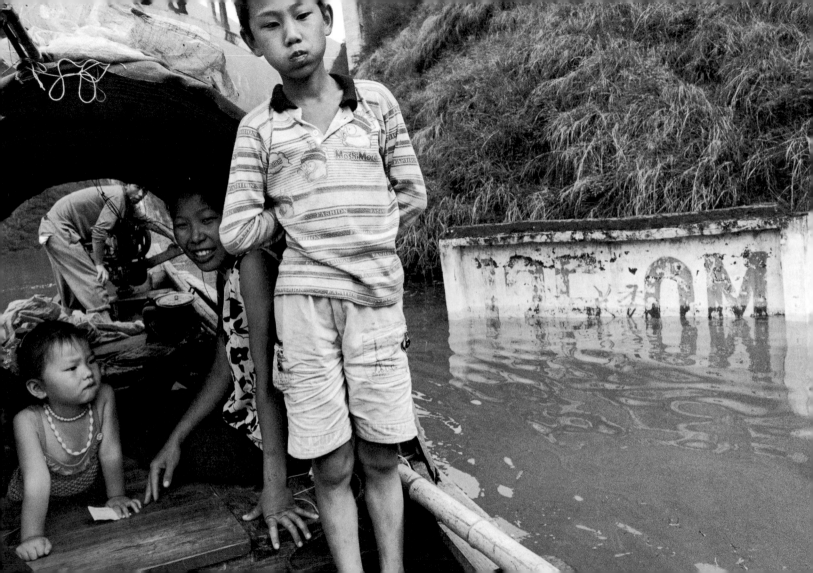

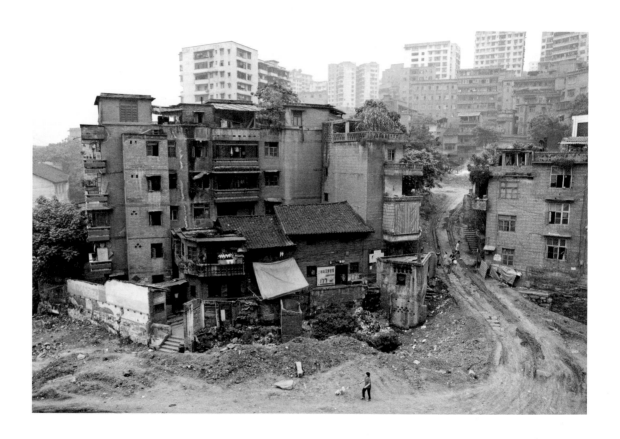

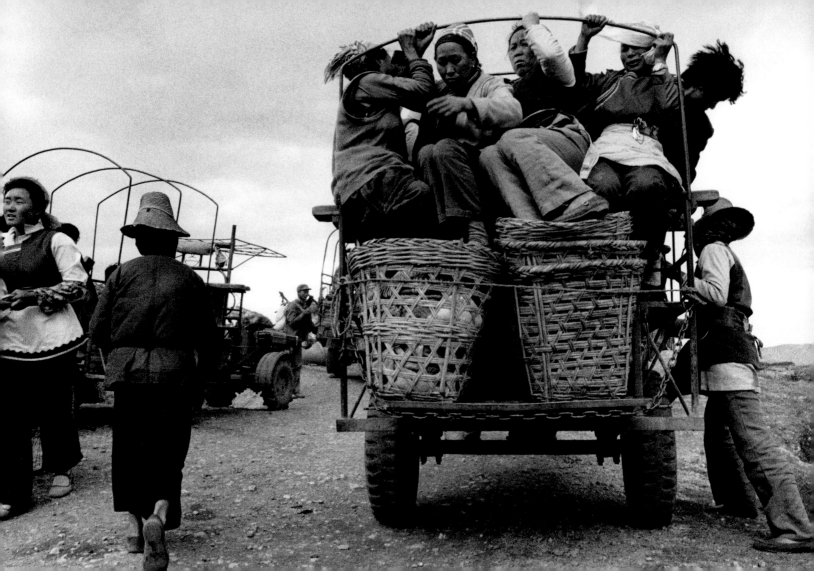

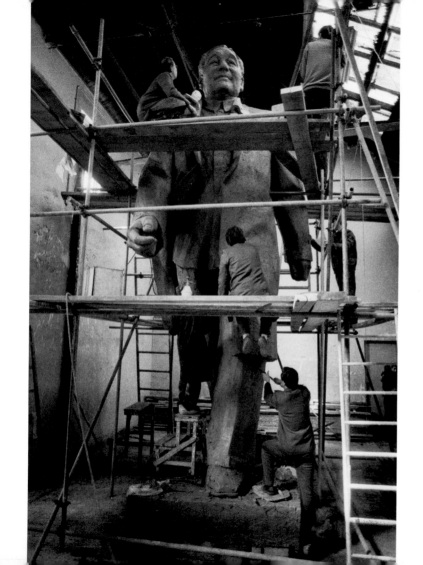

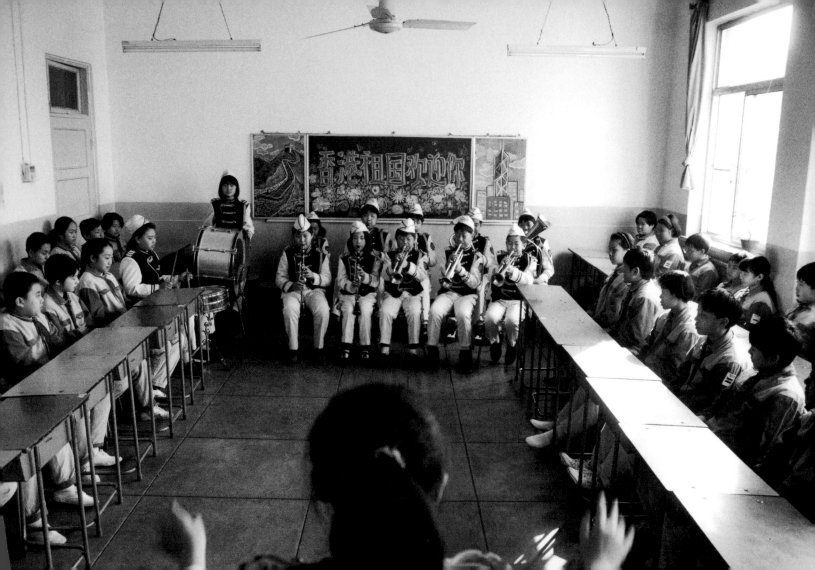

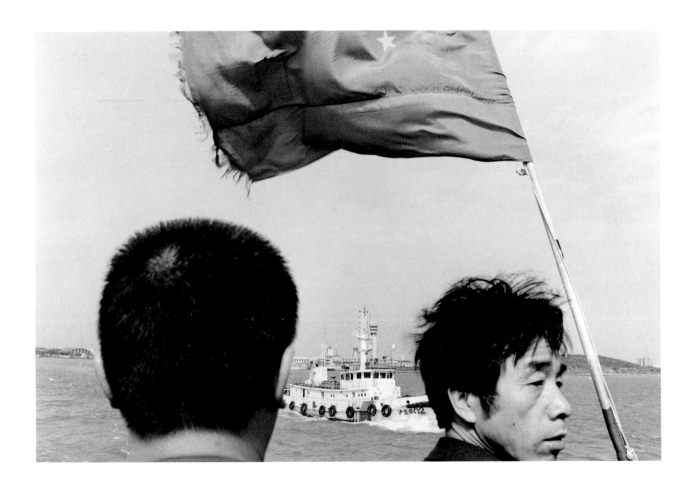

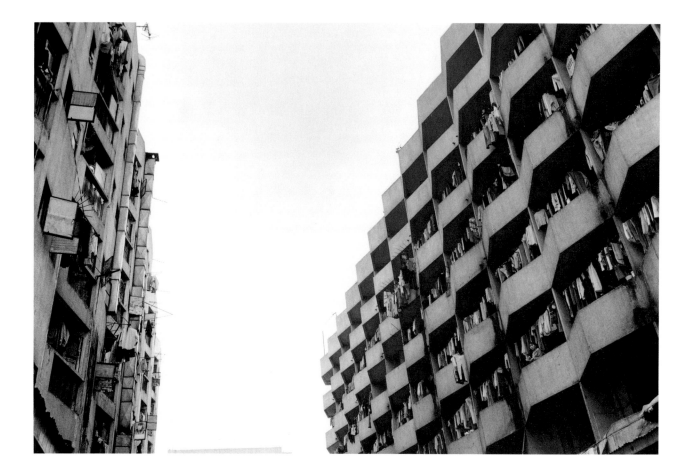

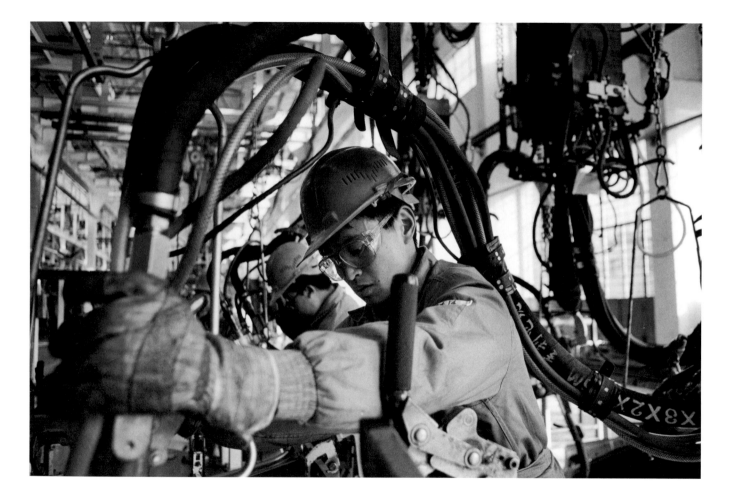

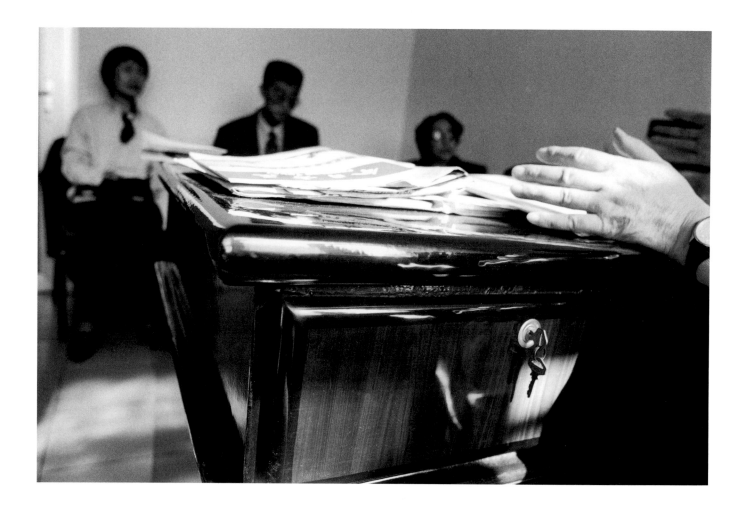

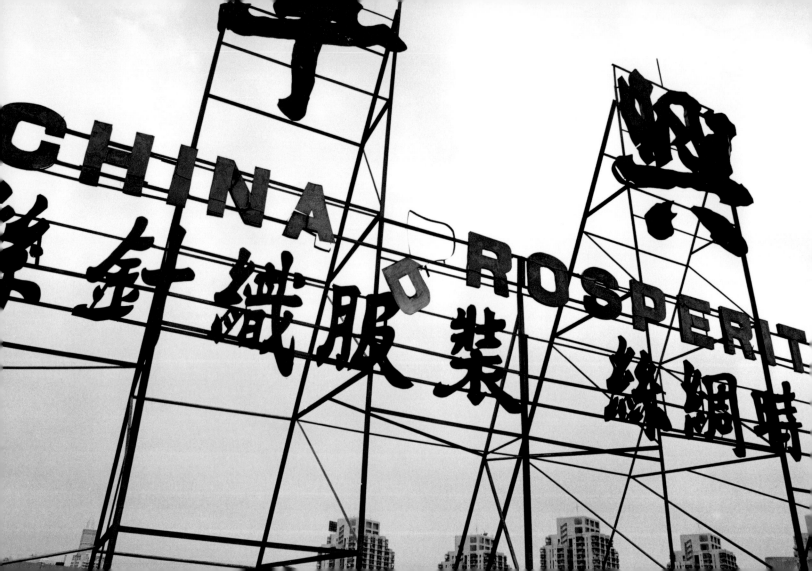

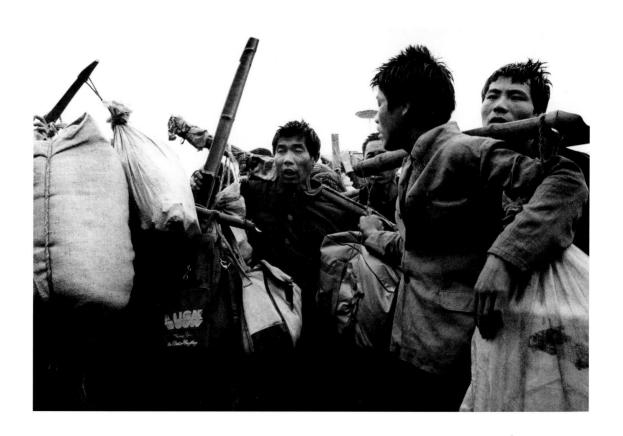

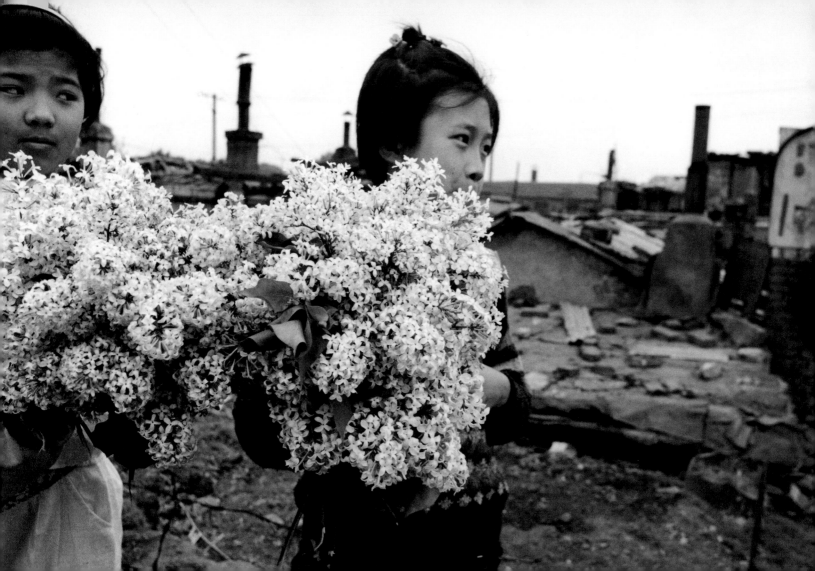

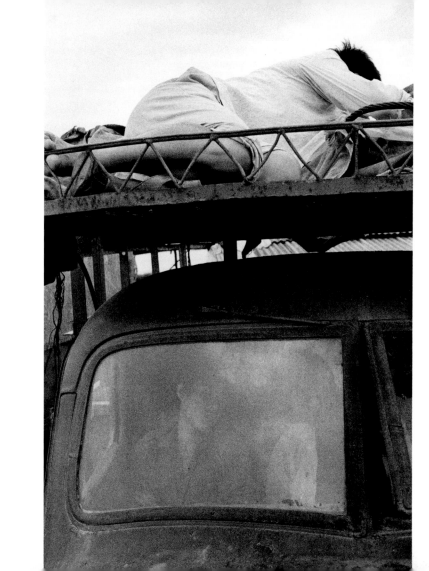

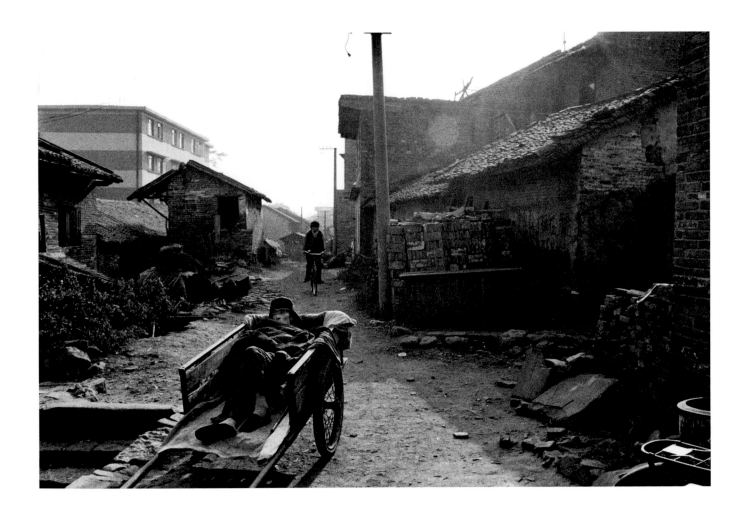

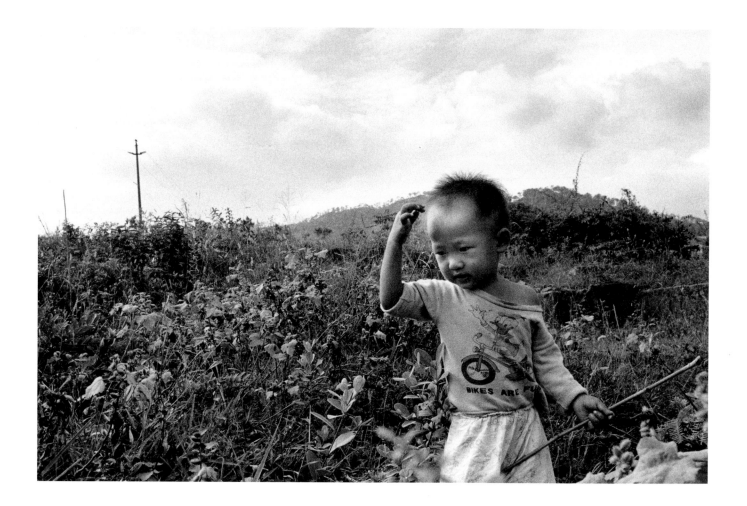

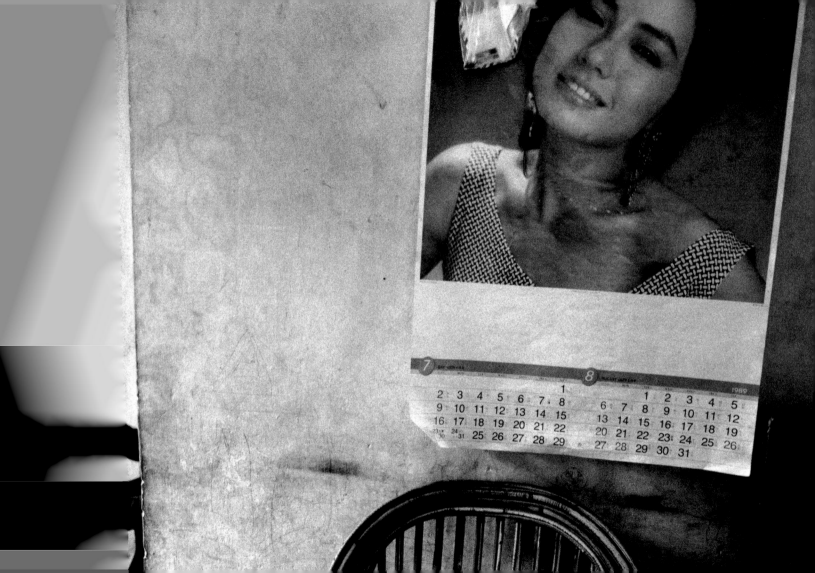

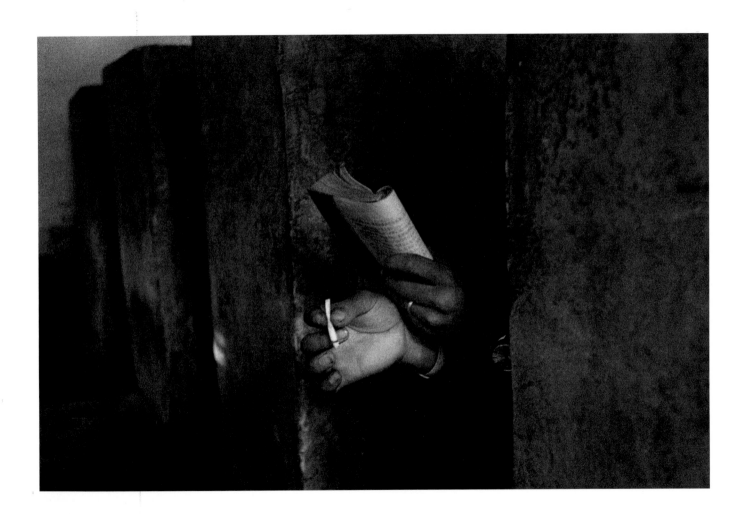

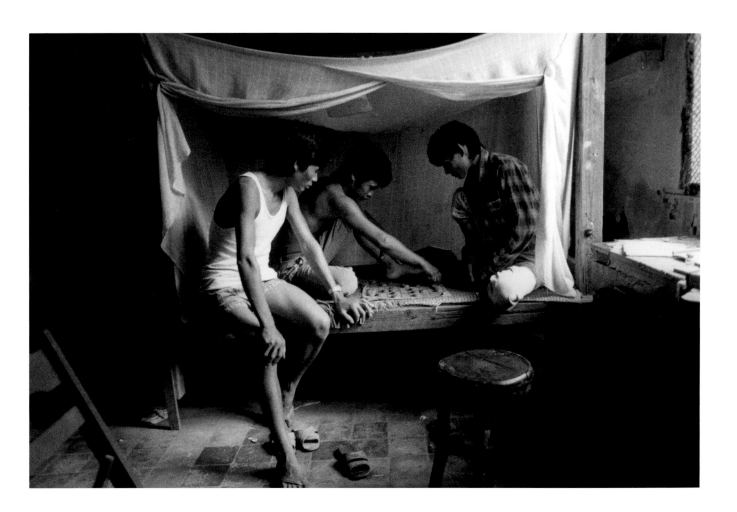

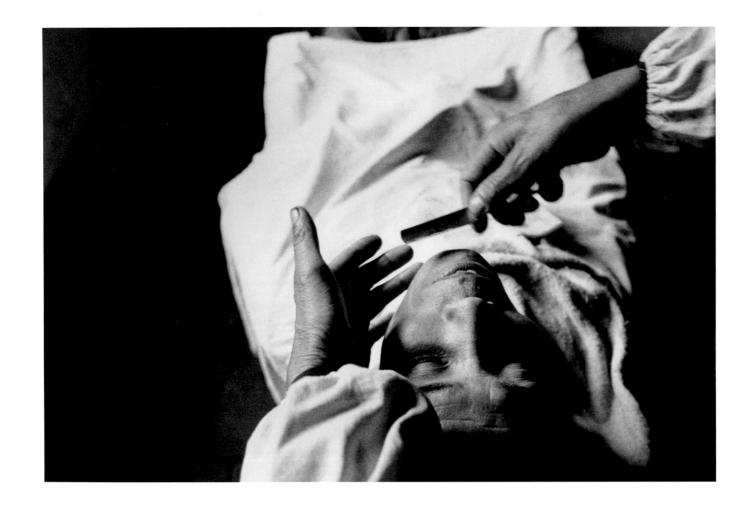

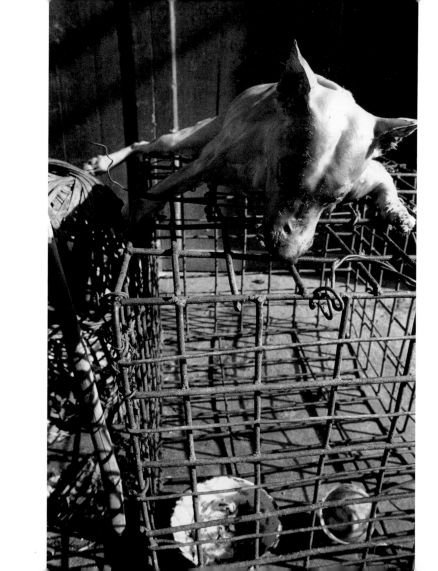

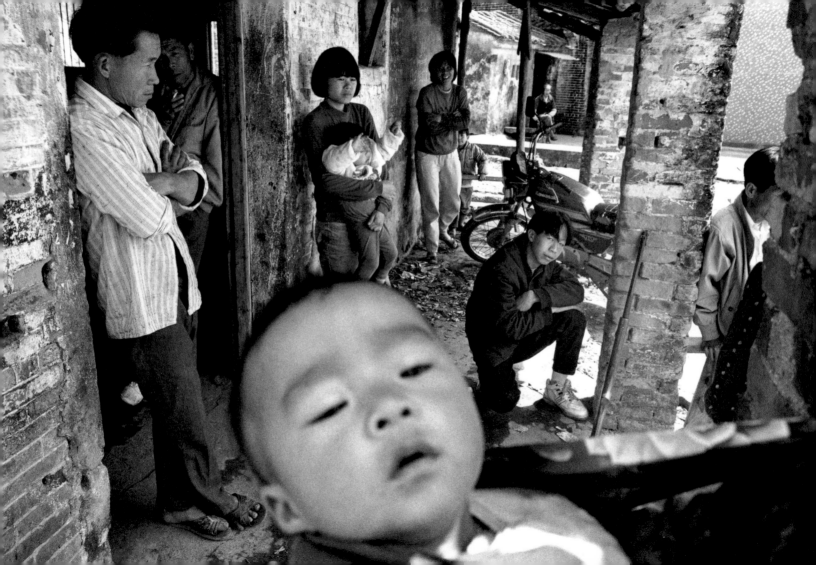

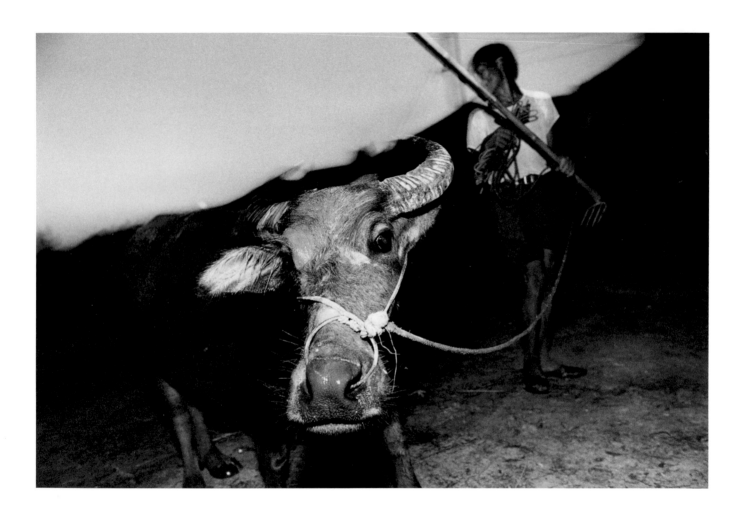

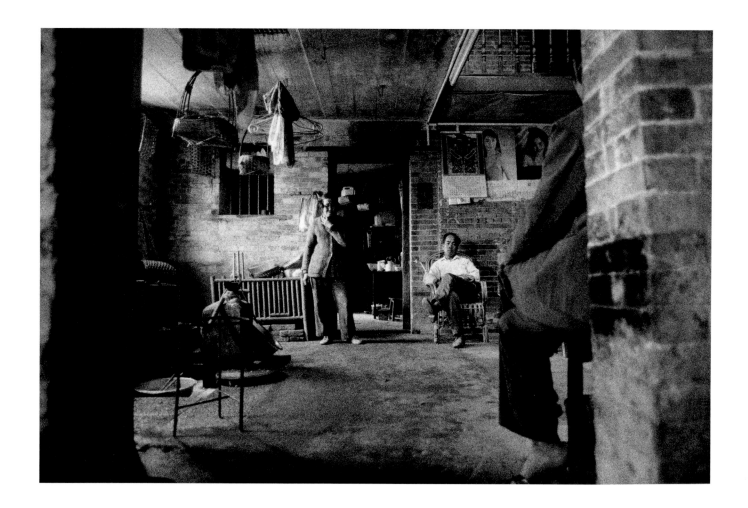

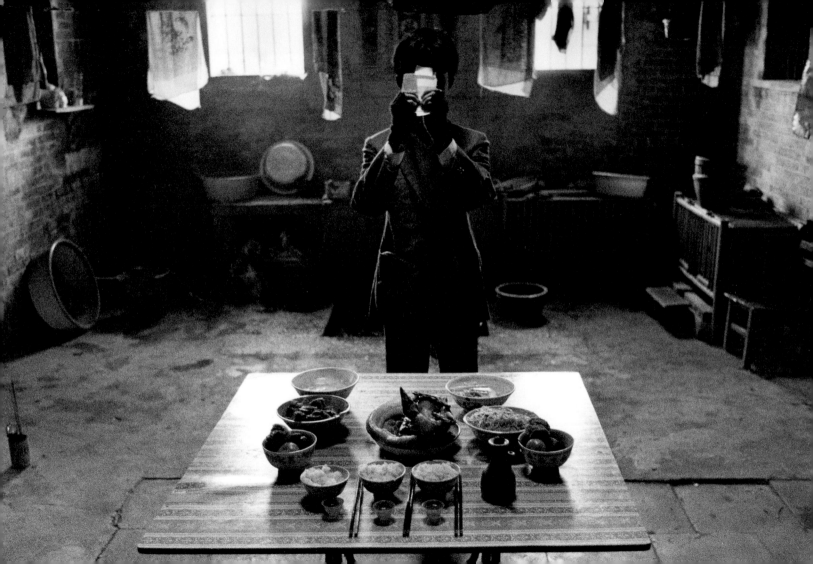

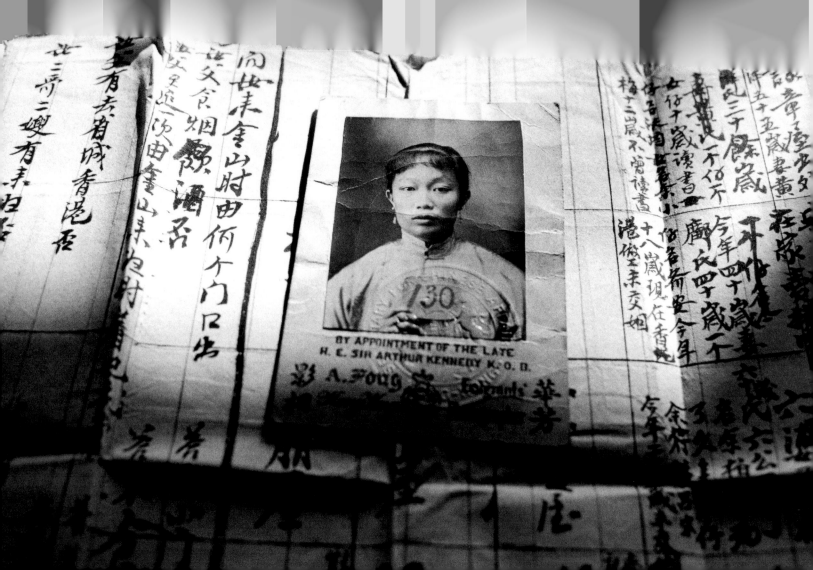

BY APPOINTMENT OF THE LATE
H. E. SIR ARTHUR KENNEDY K.C.O.B.

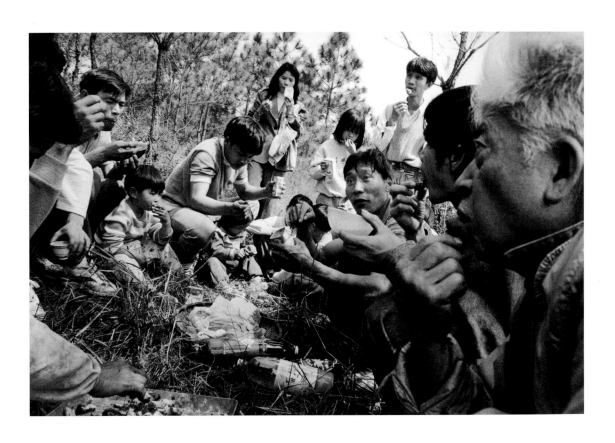

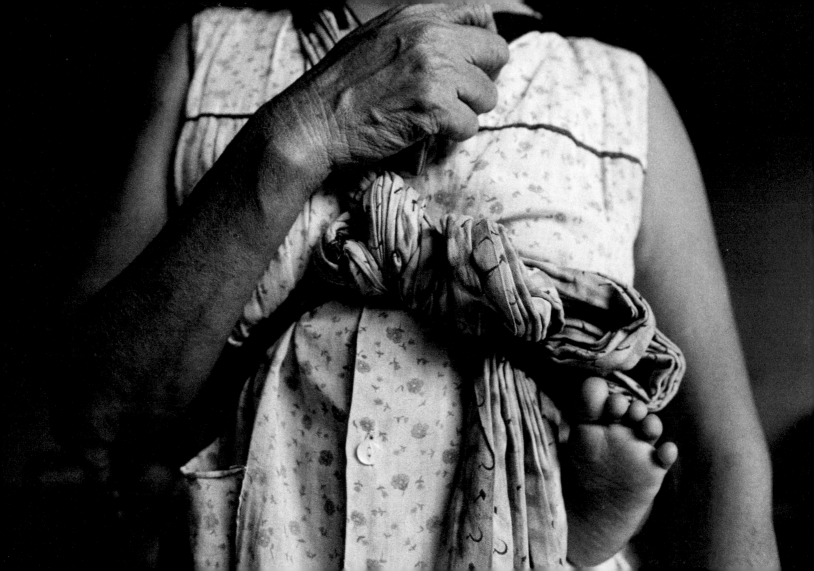

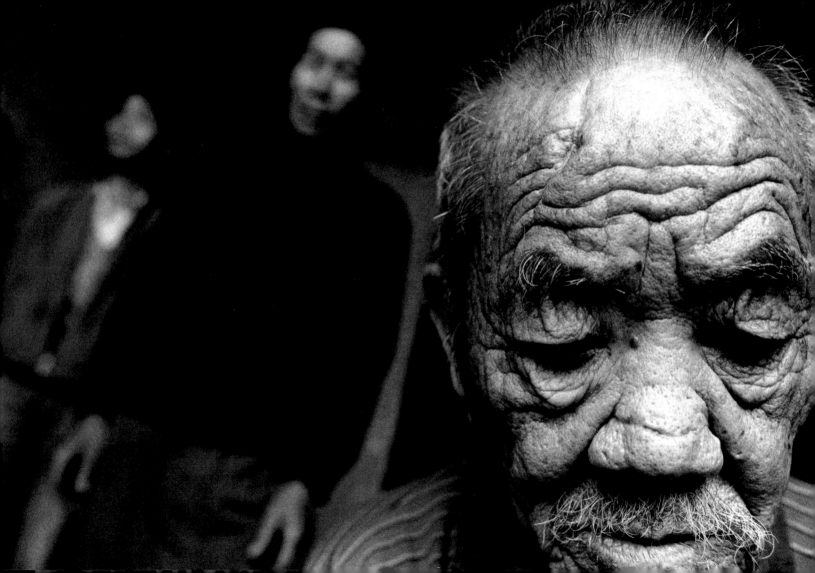

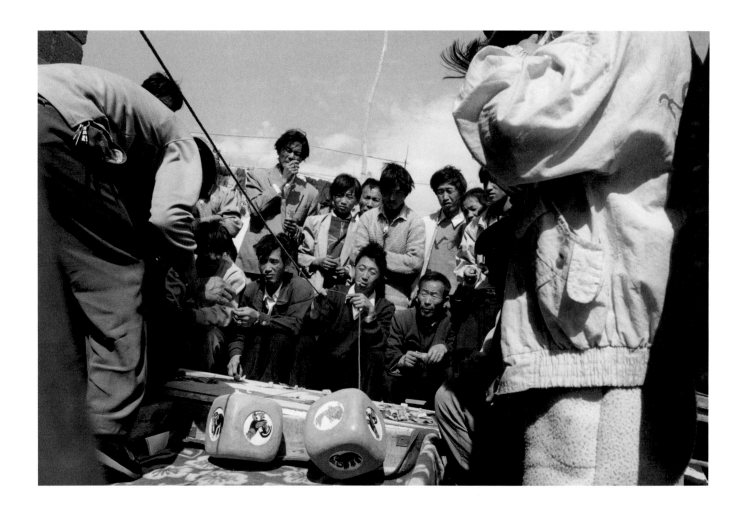

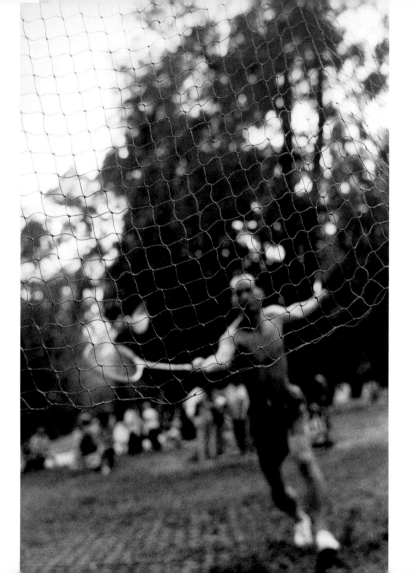

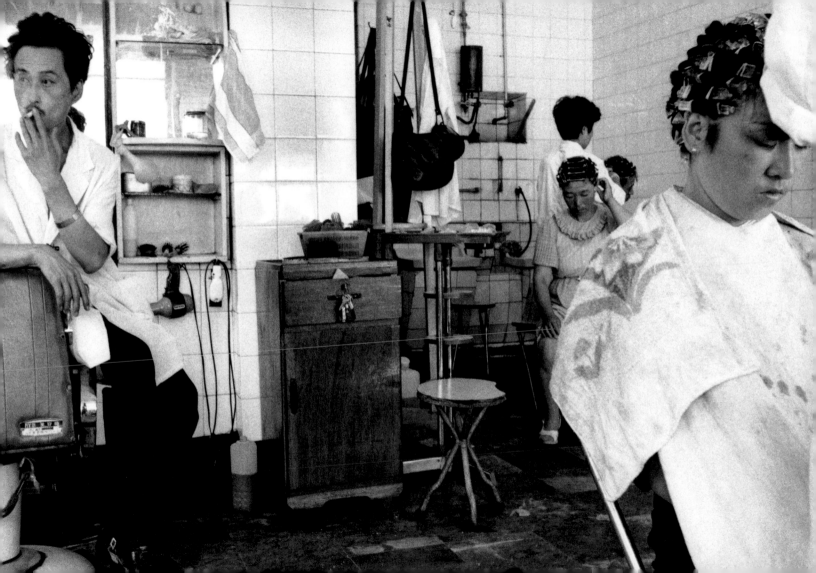

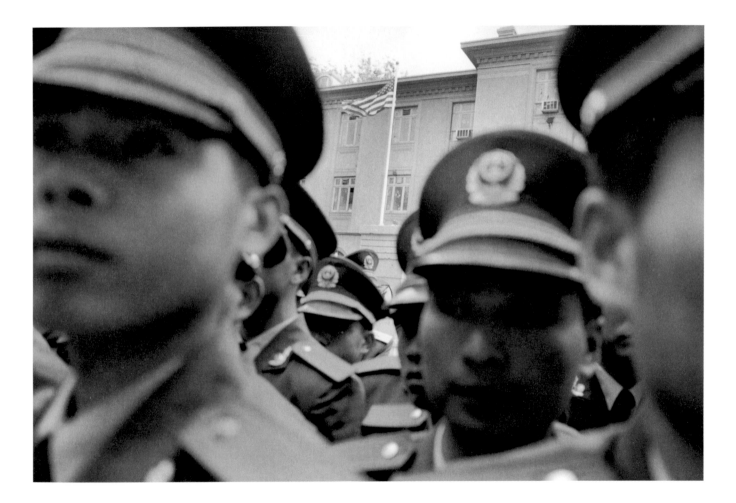

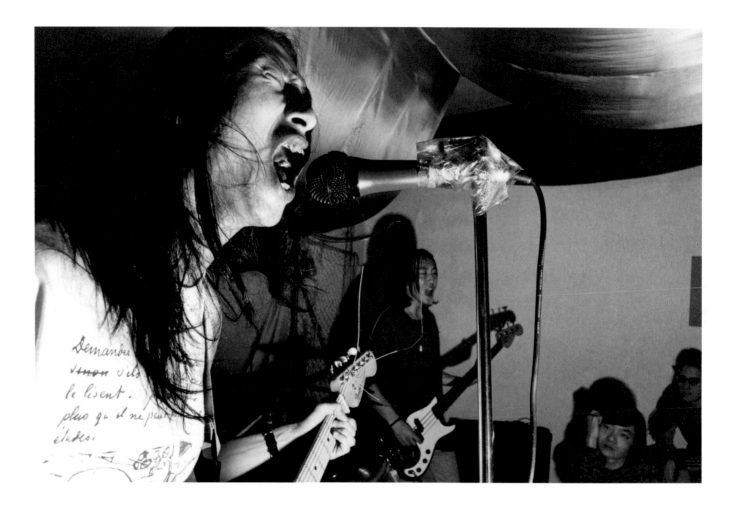

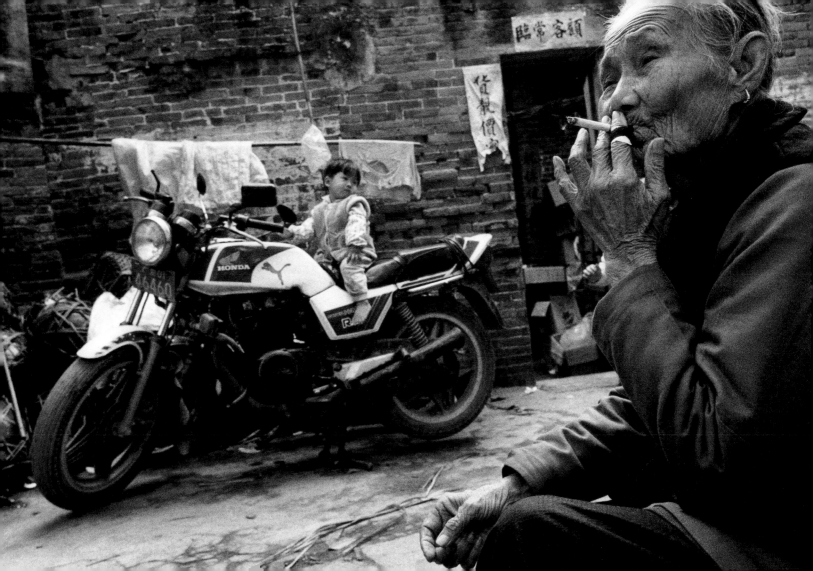

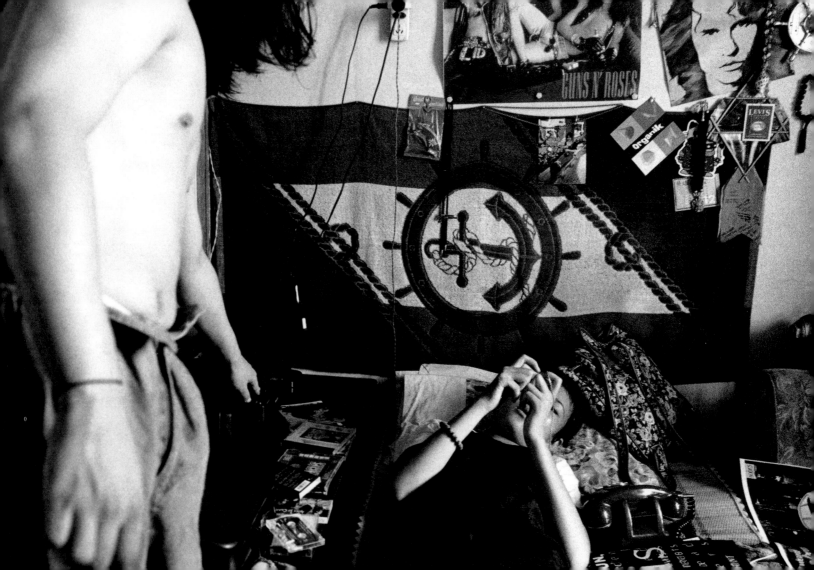

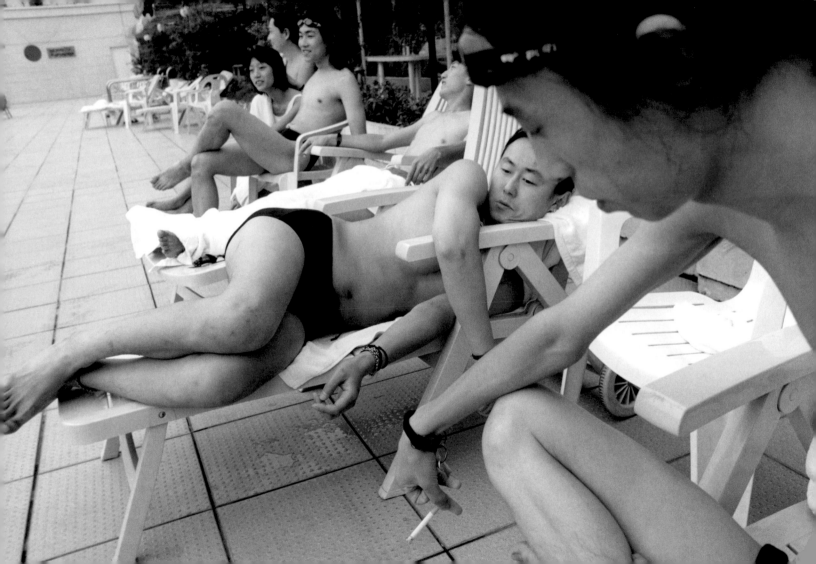

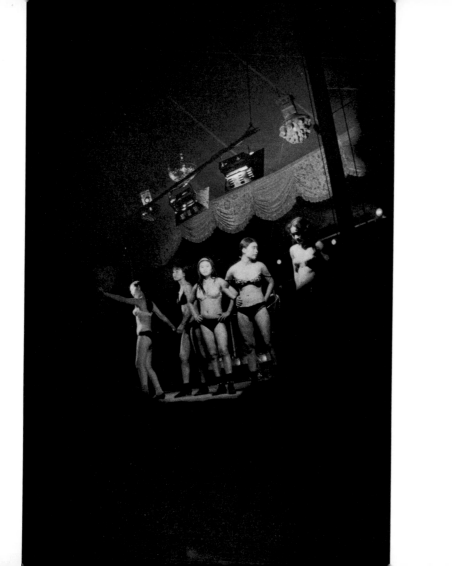

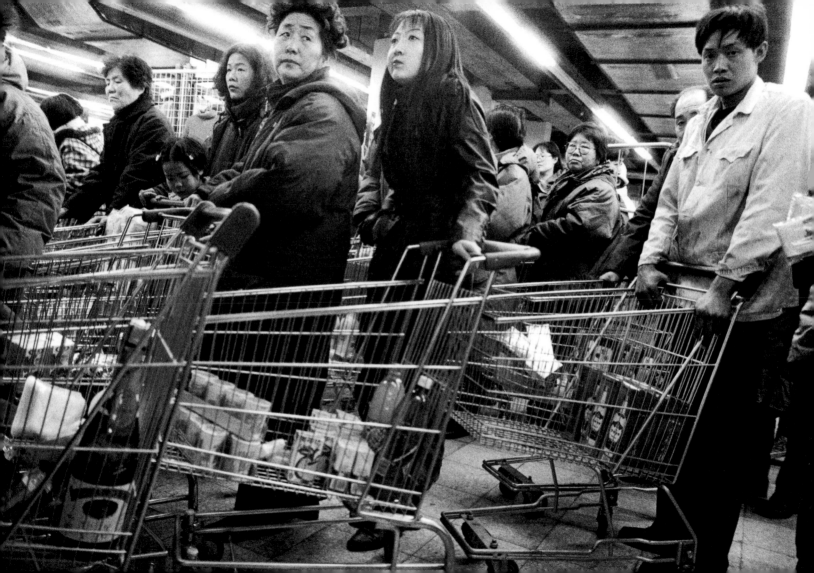

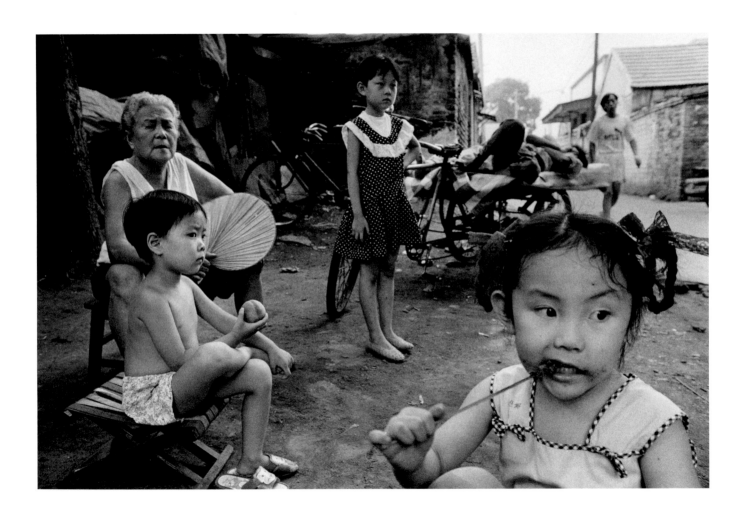

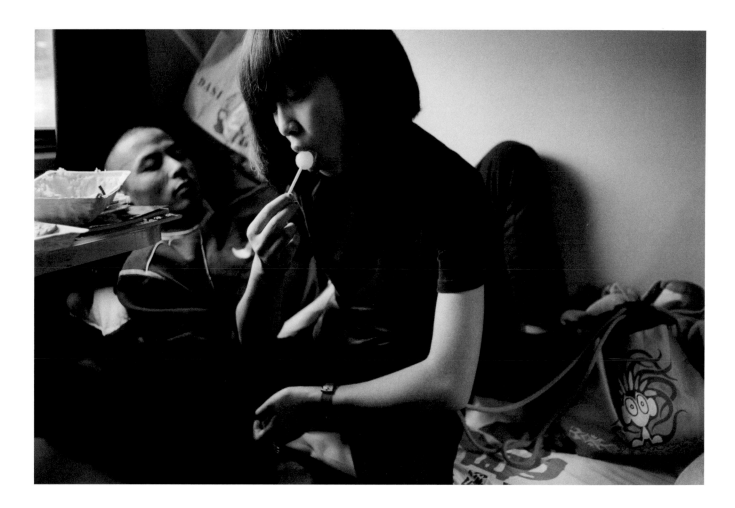

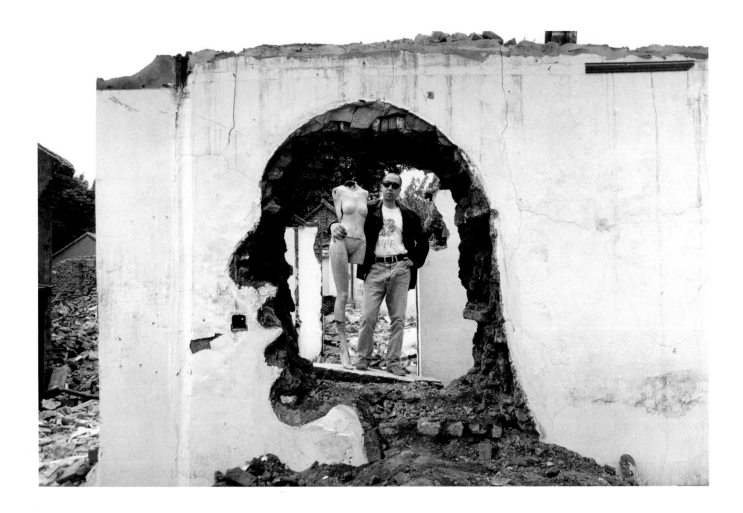

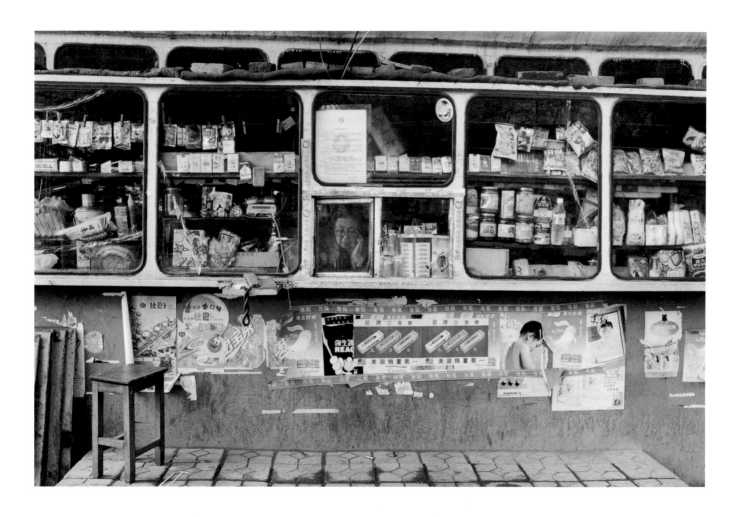

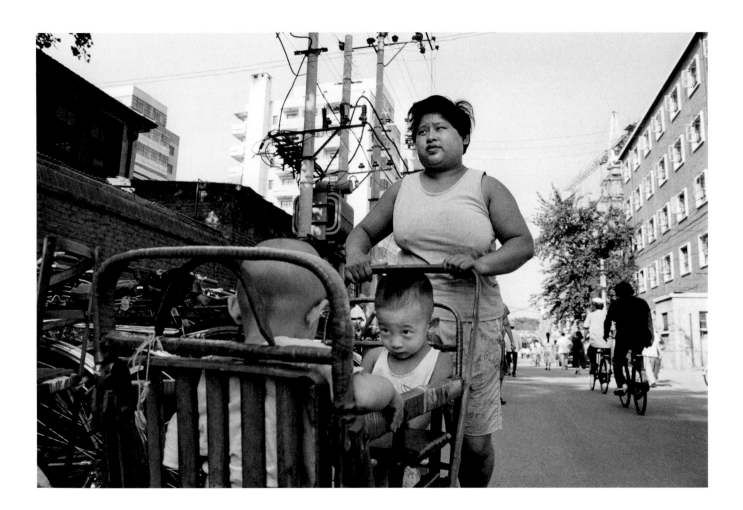

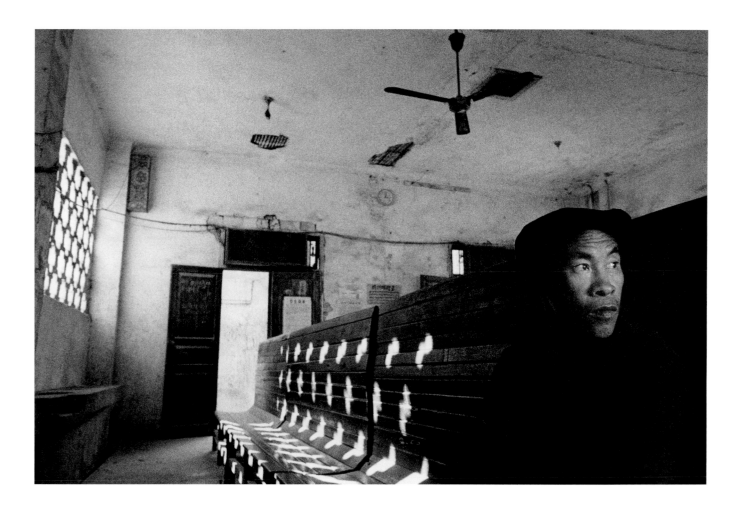

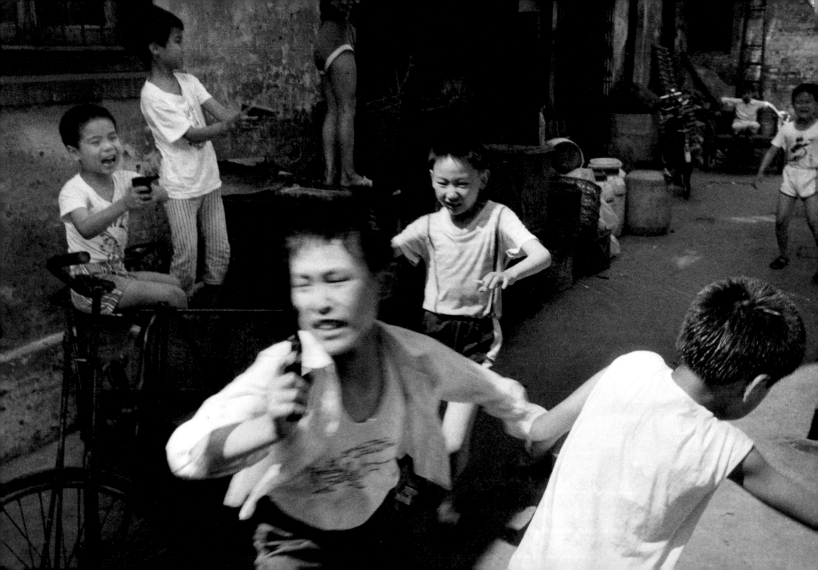

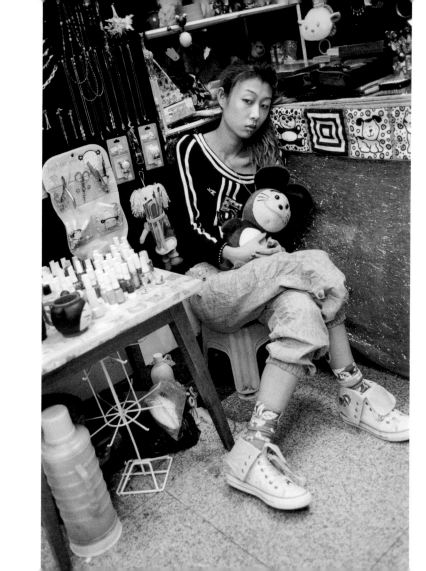

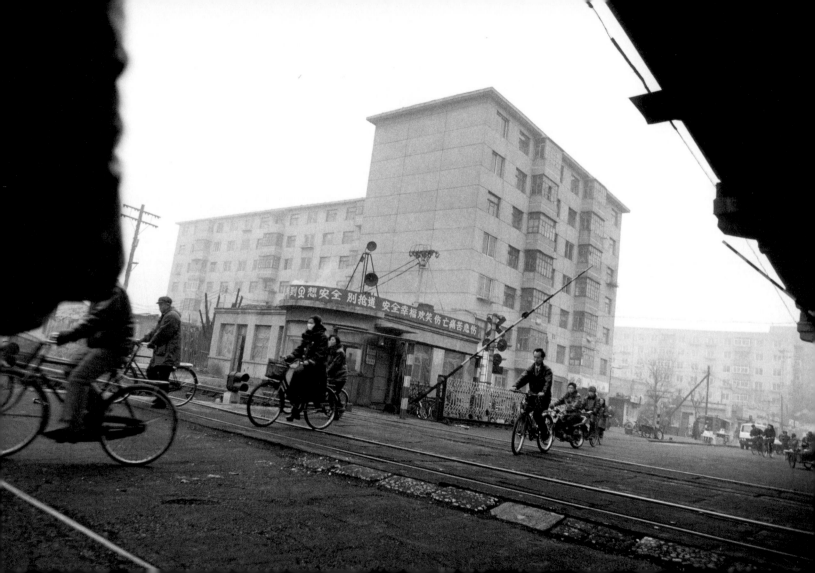

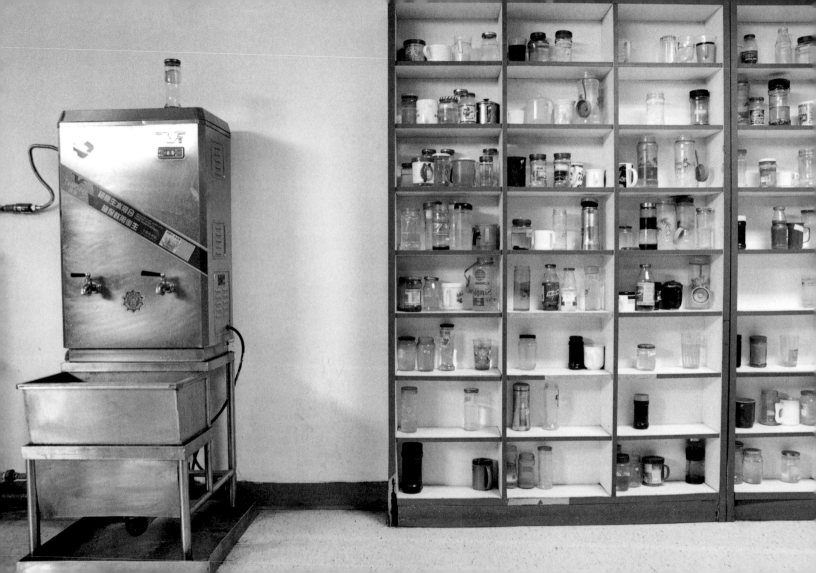

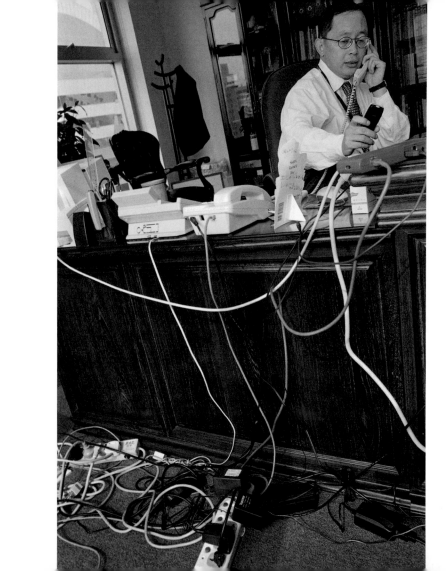

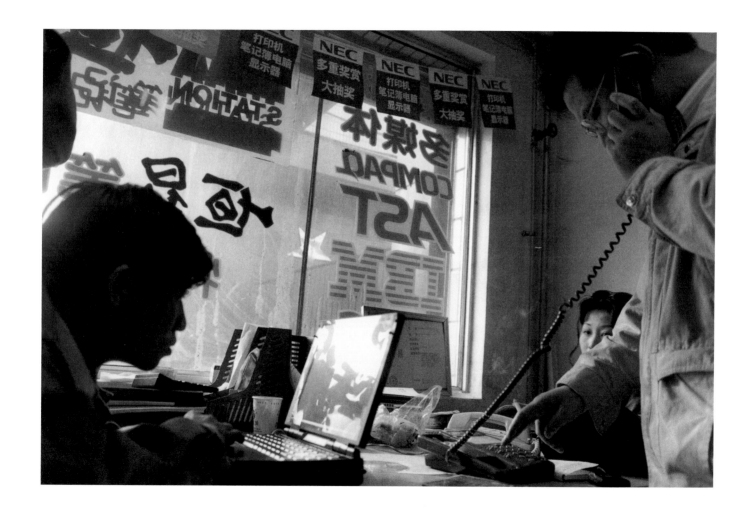

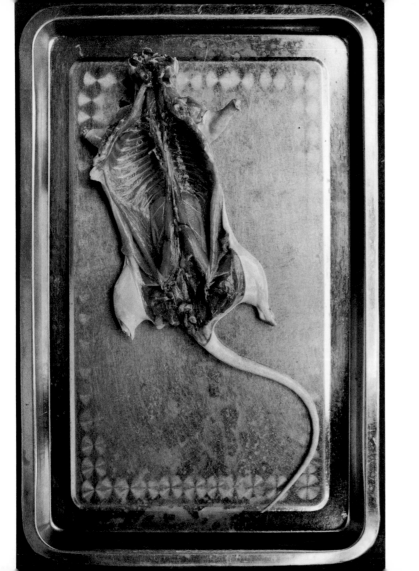

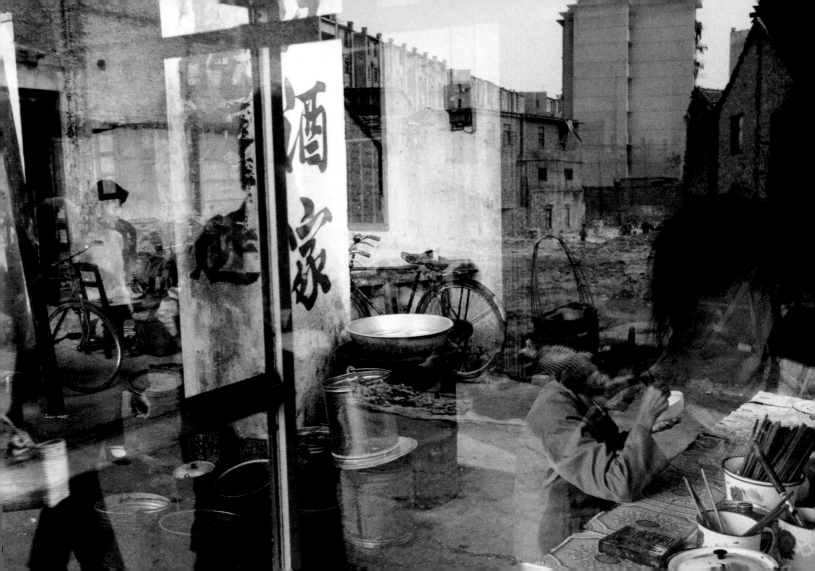

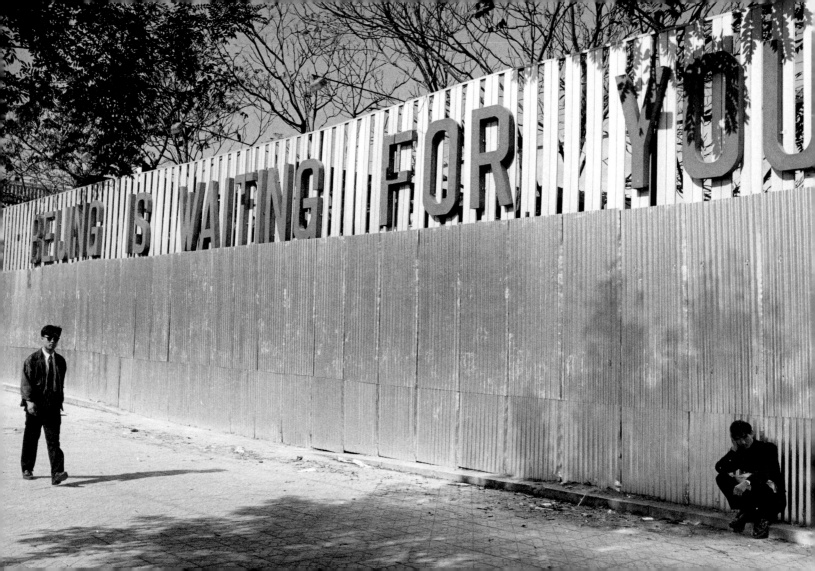

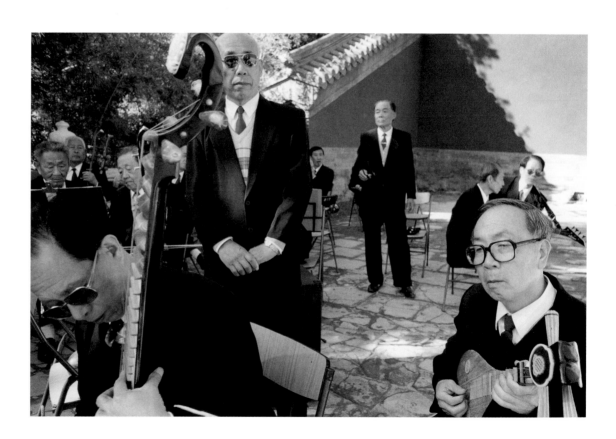

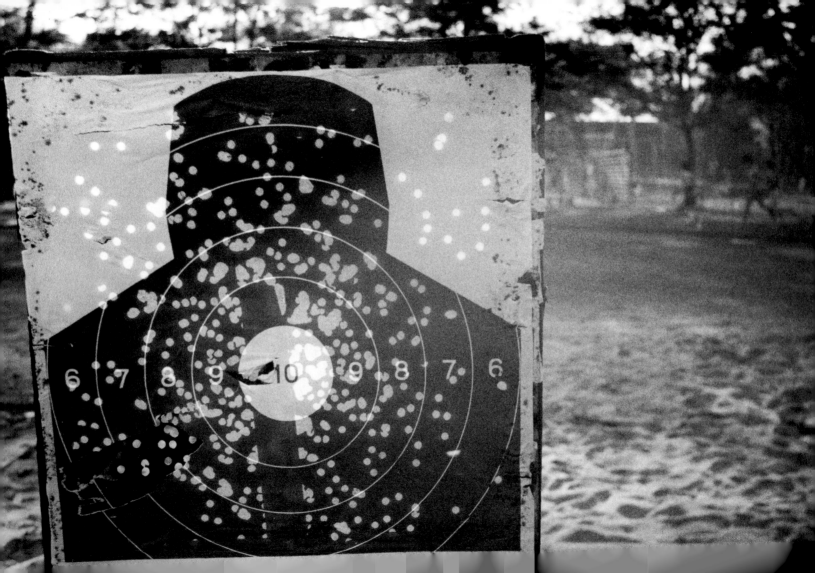

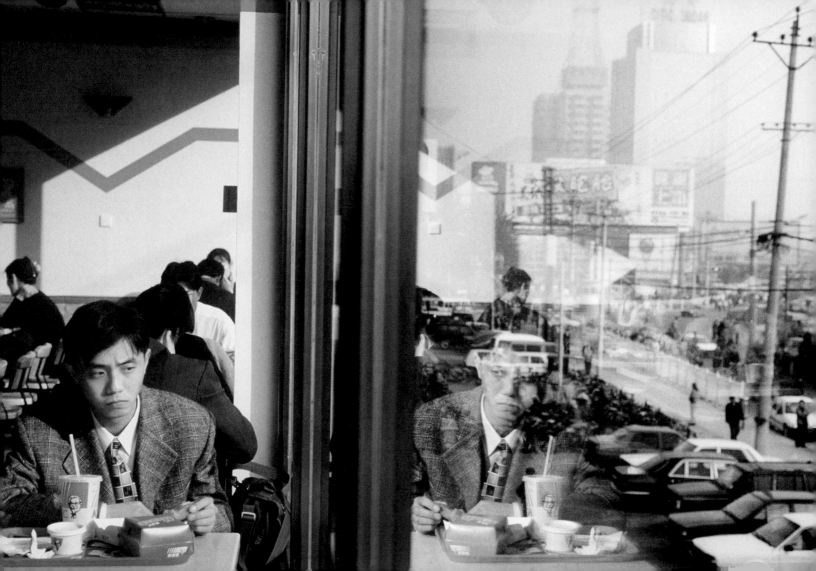

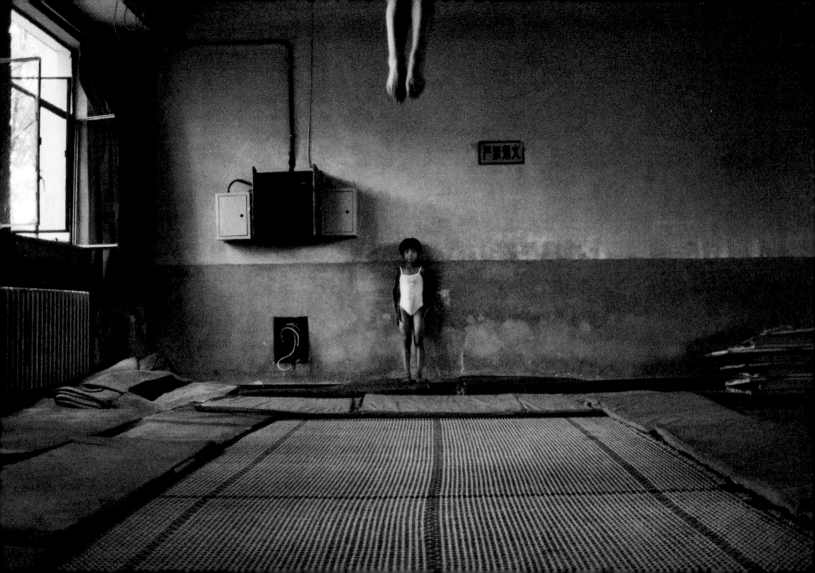

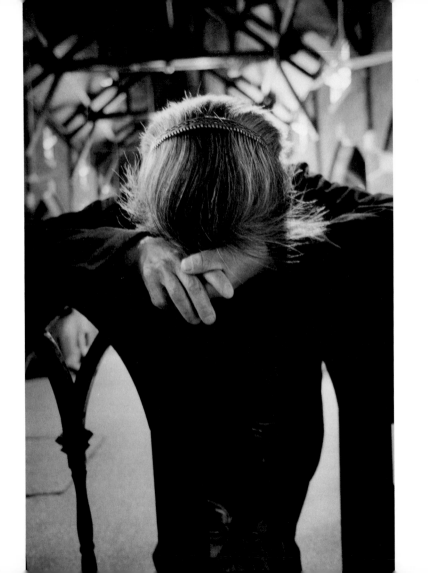

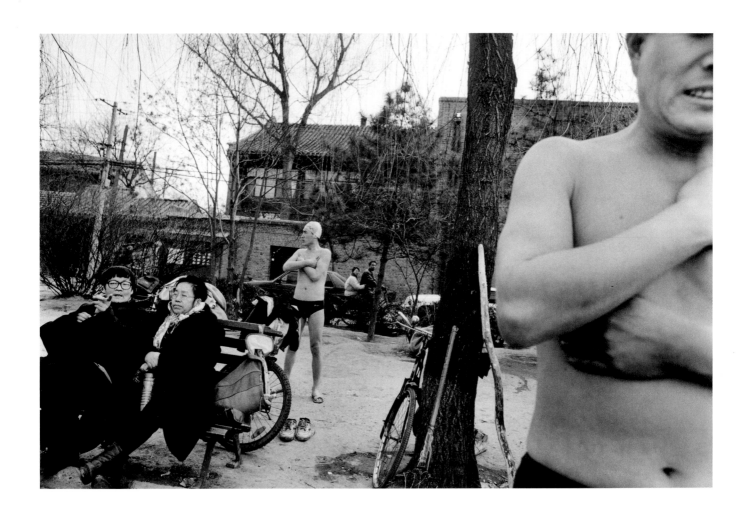

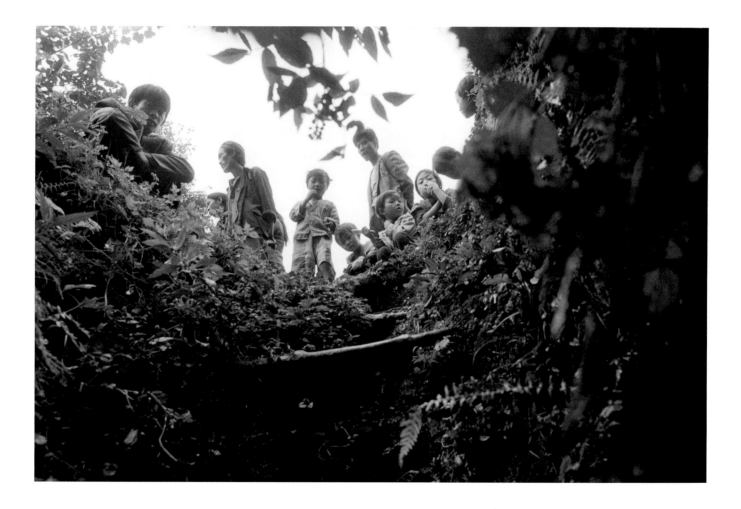

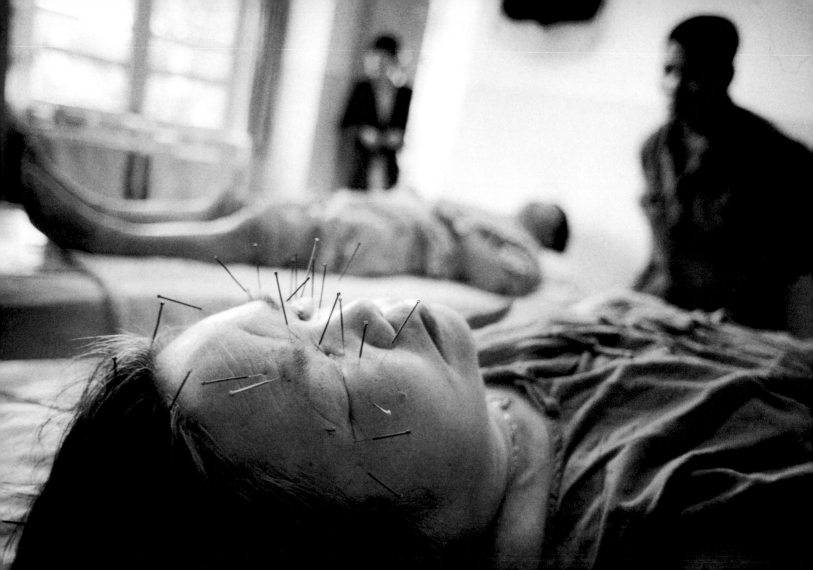

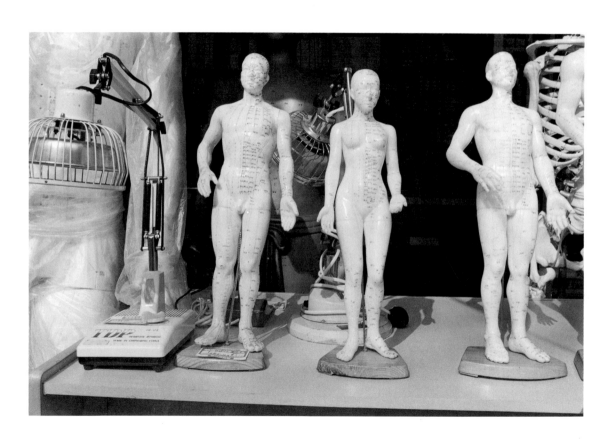

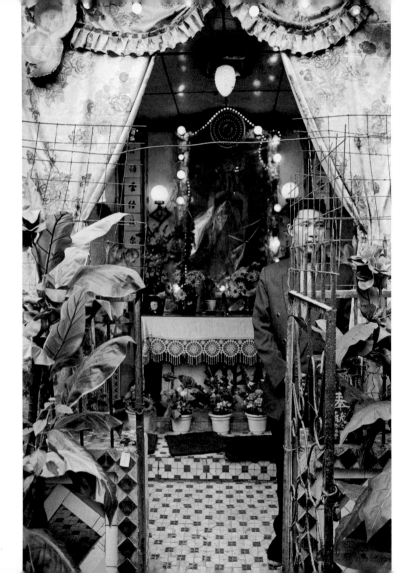

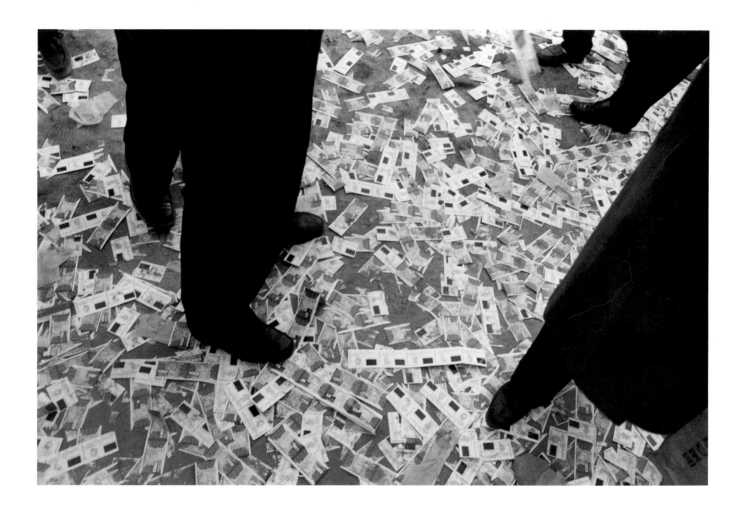

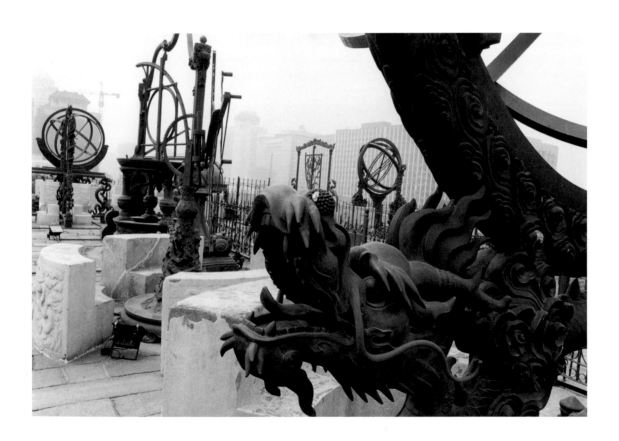

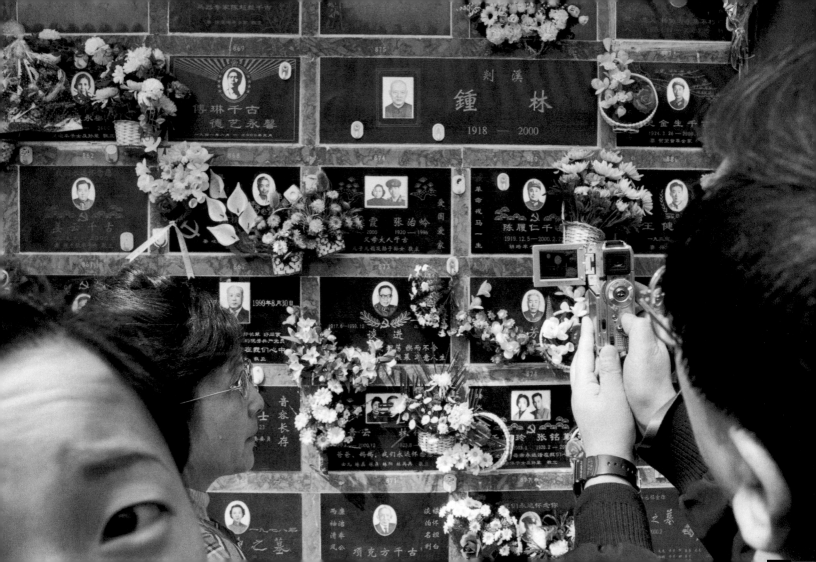

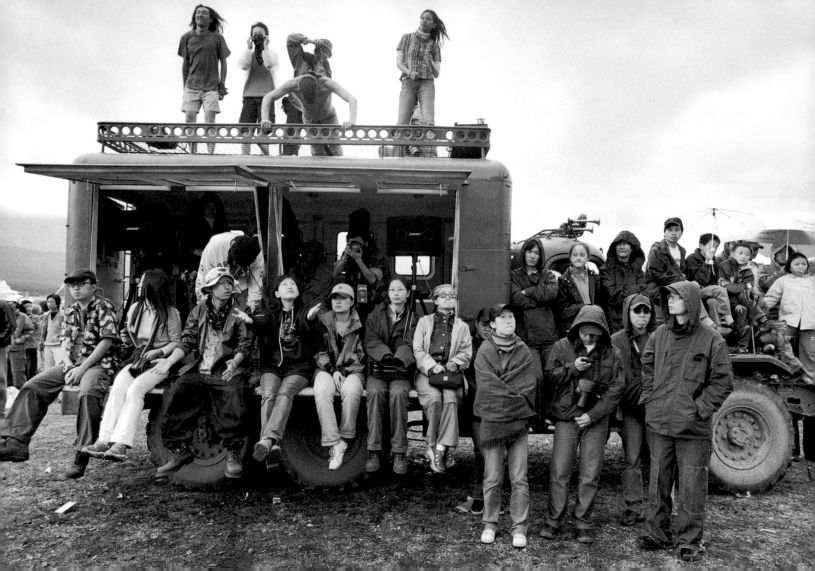

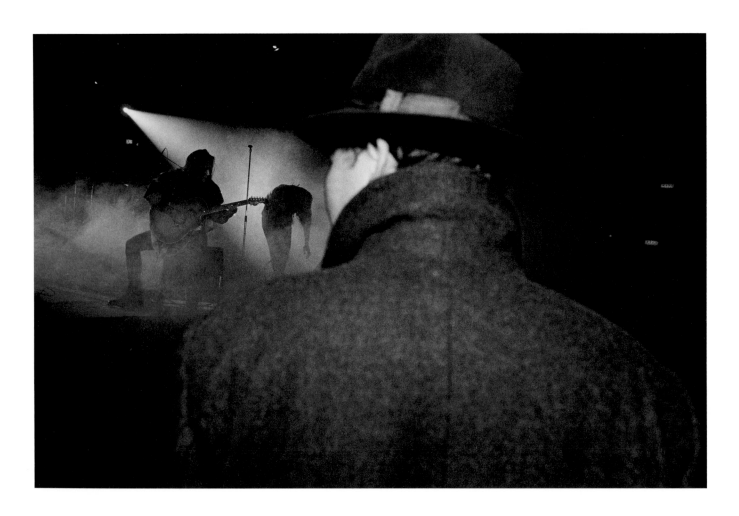

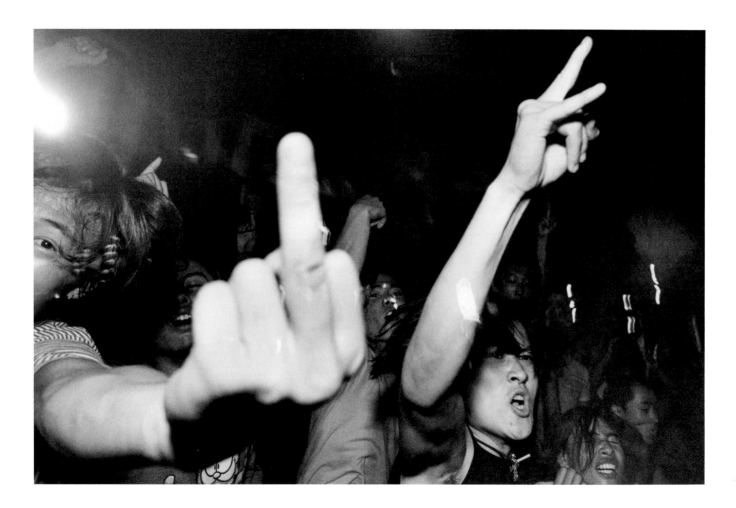

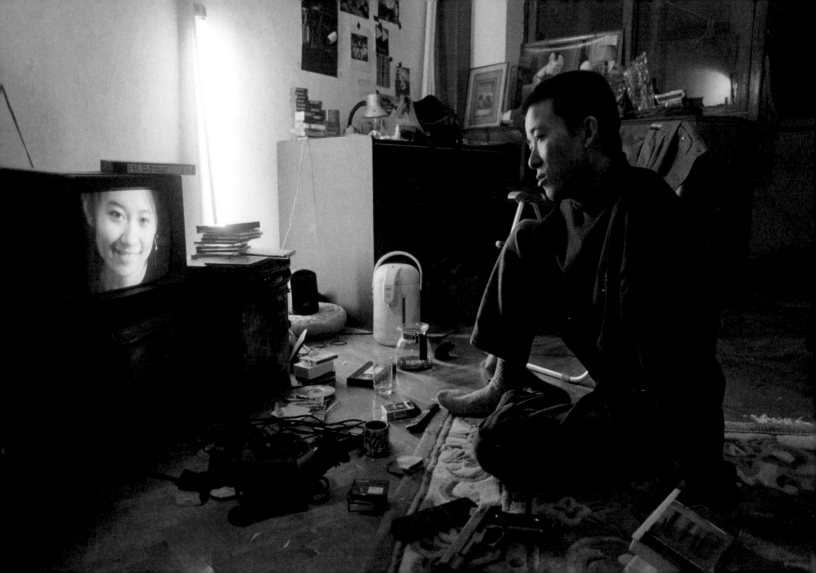

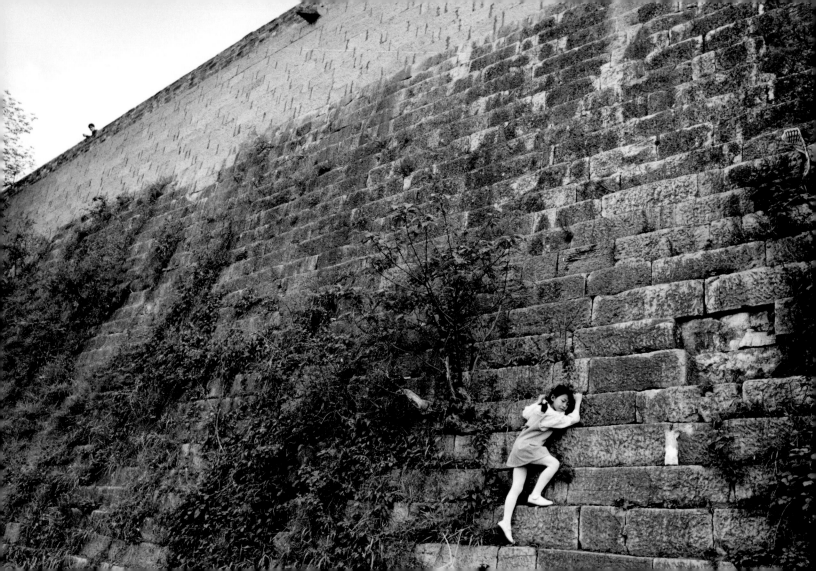

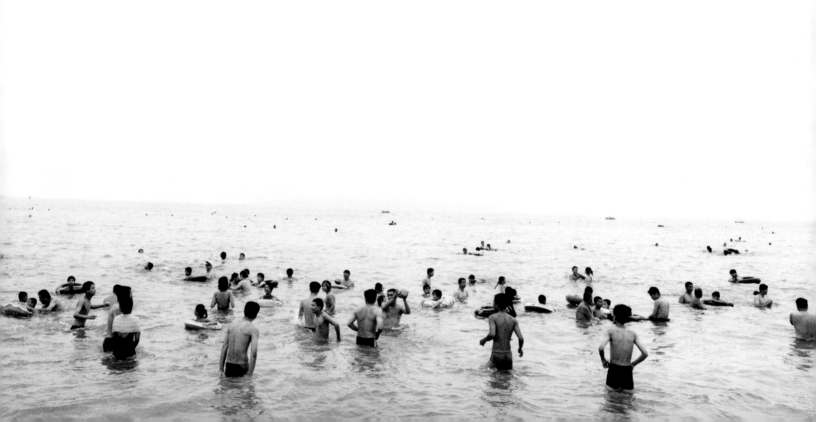

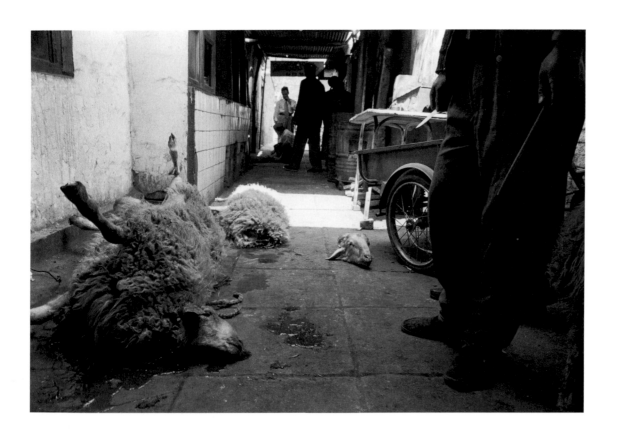

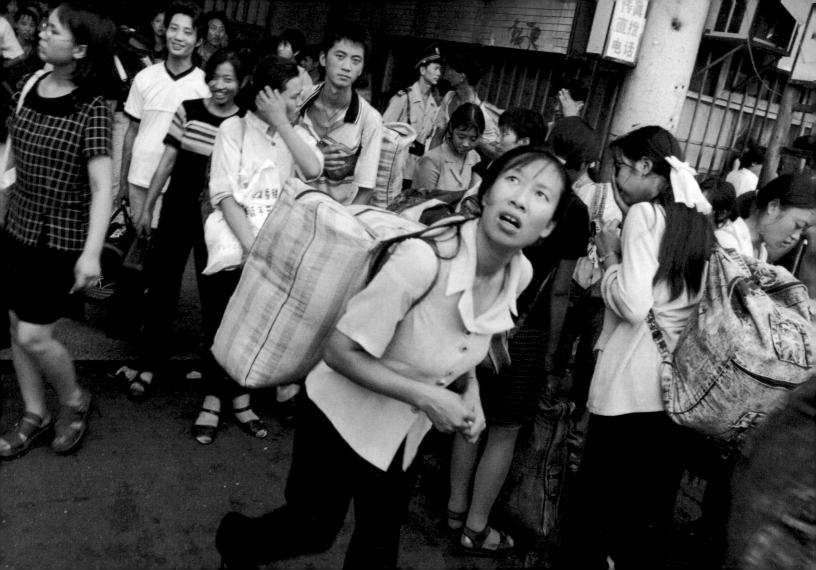

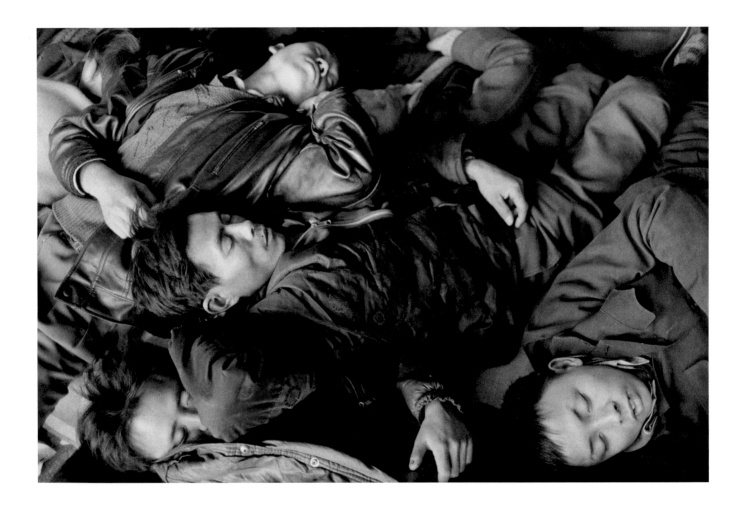

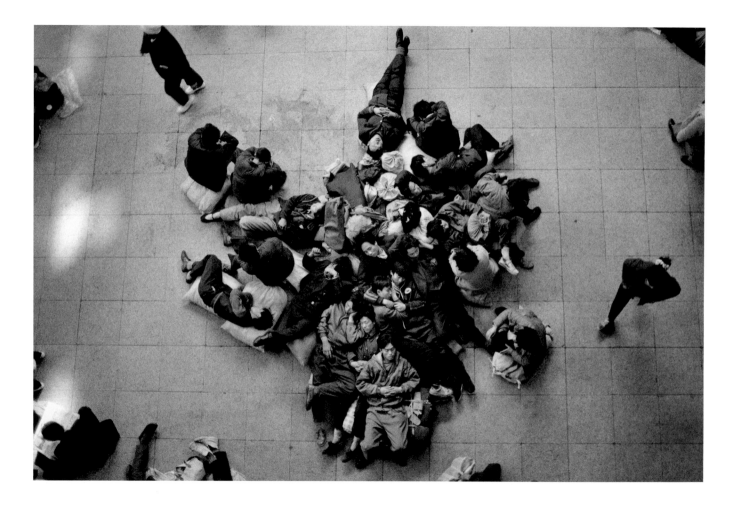

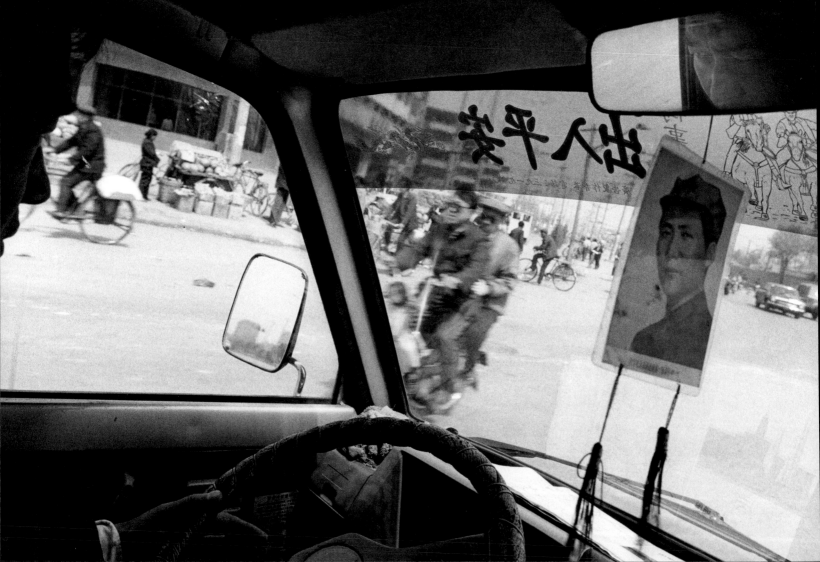

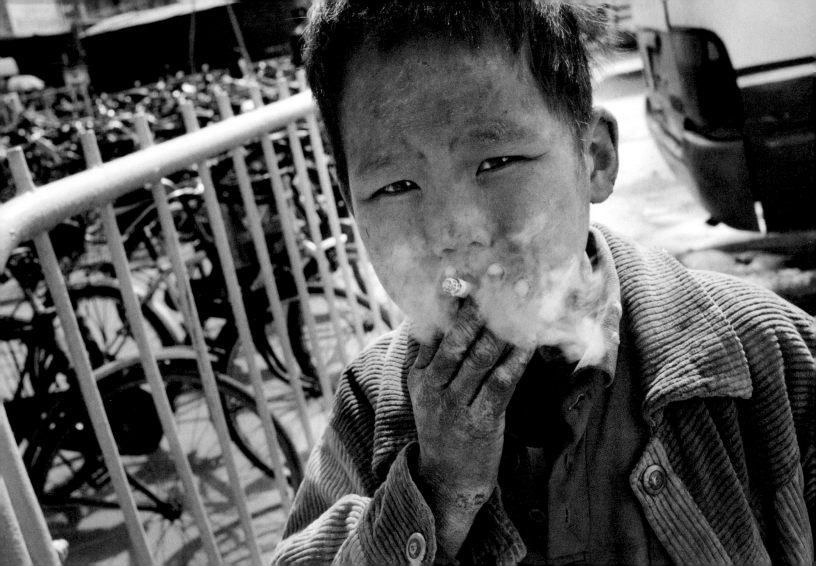

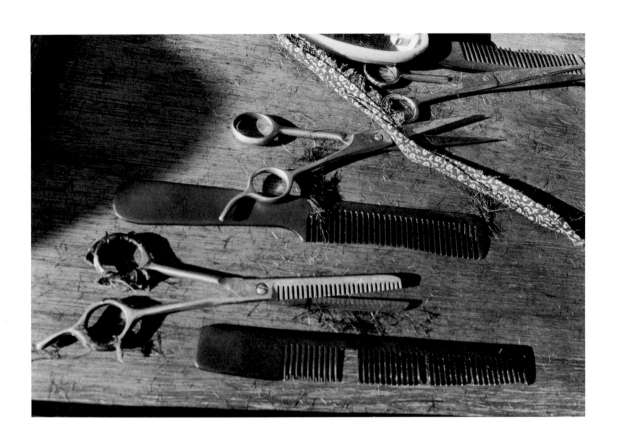

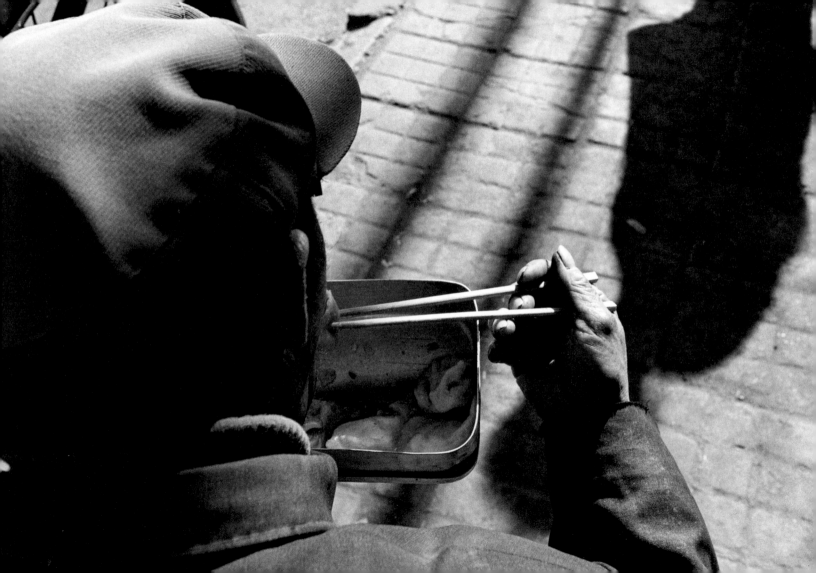

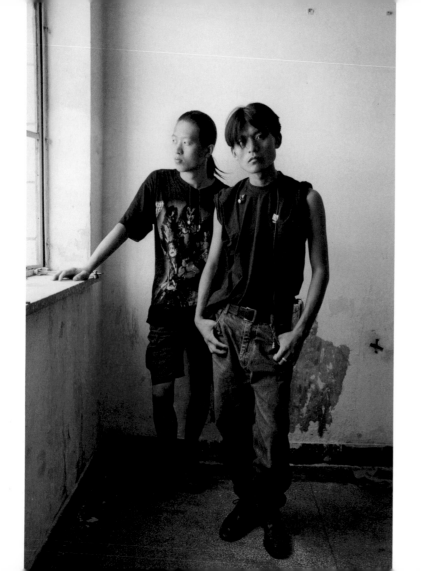

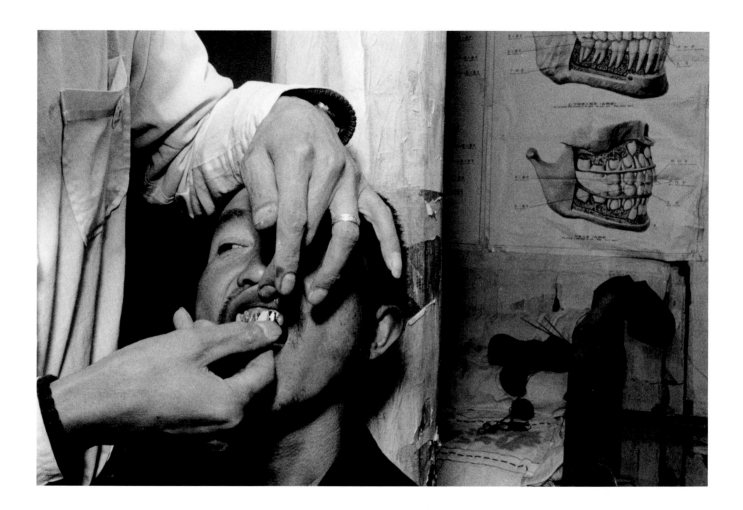

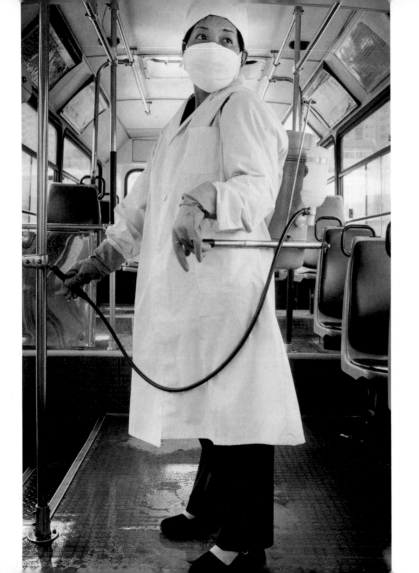

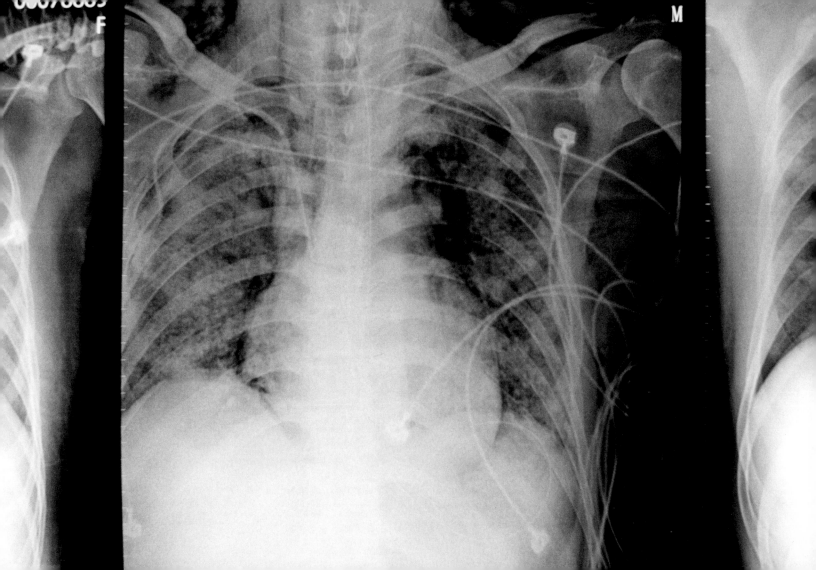

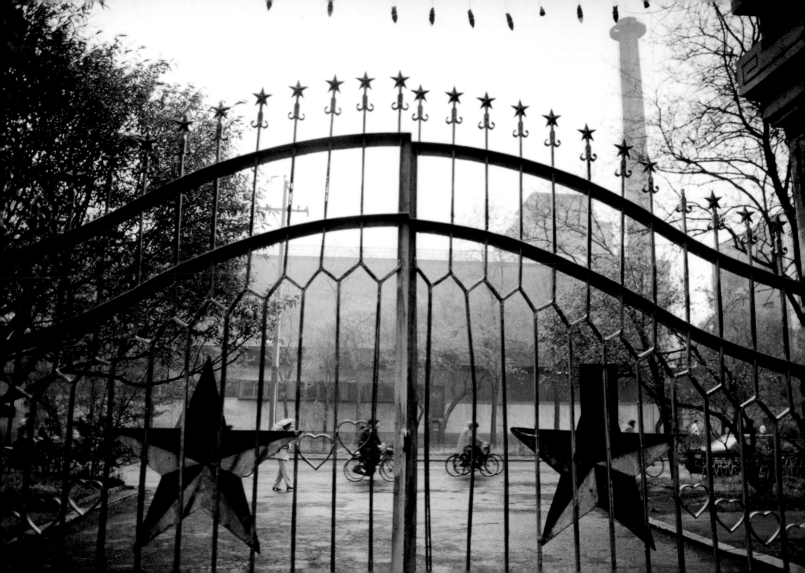

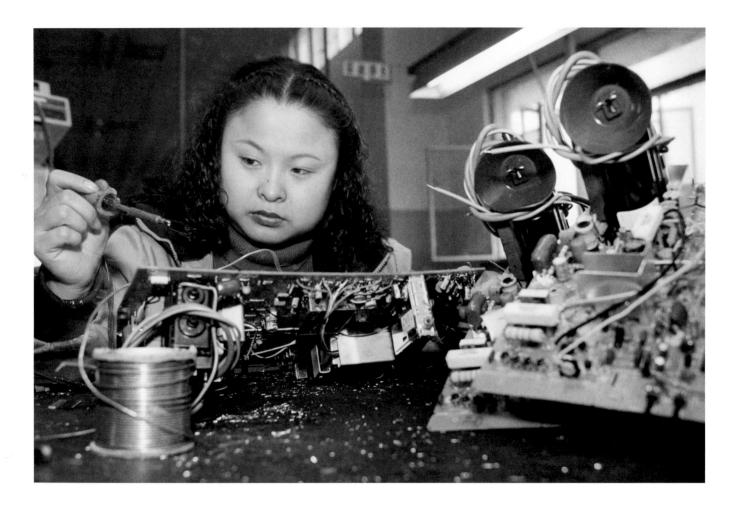

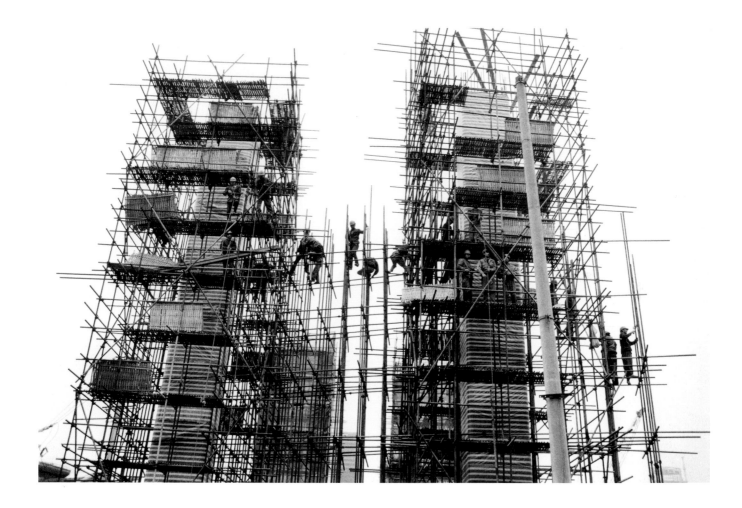

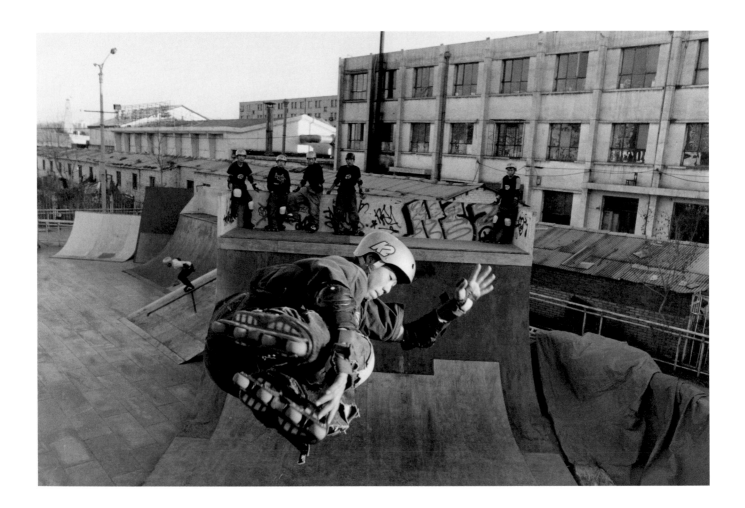

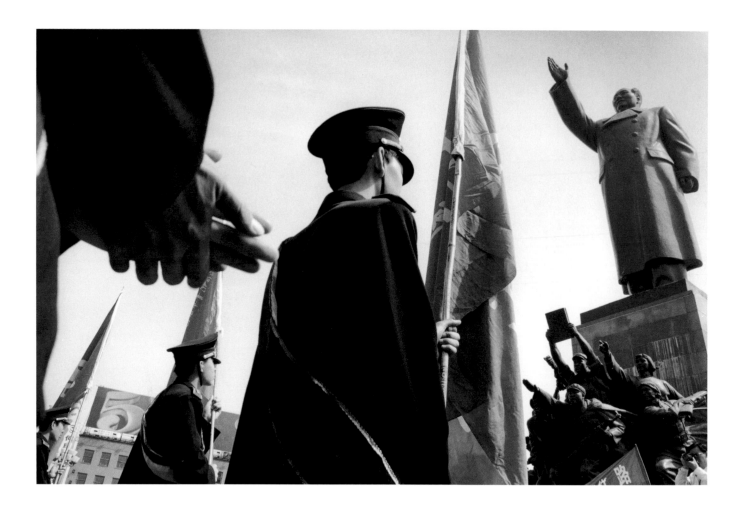

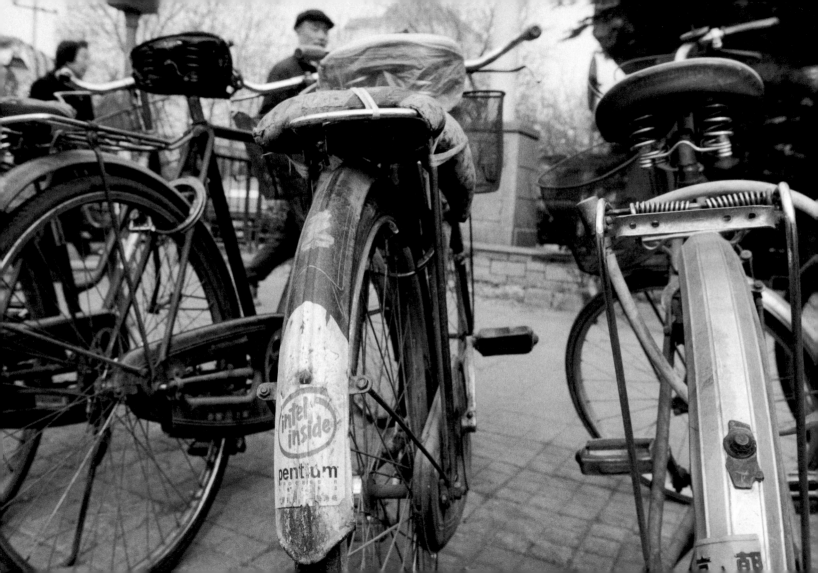

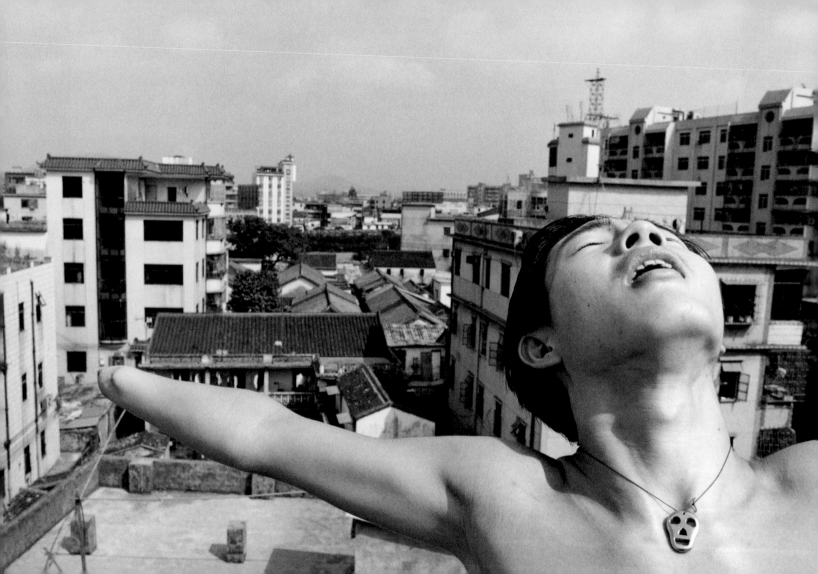

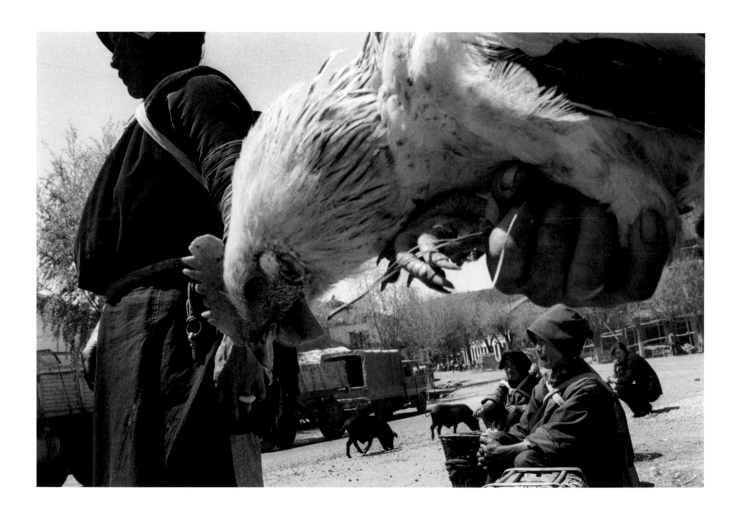

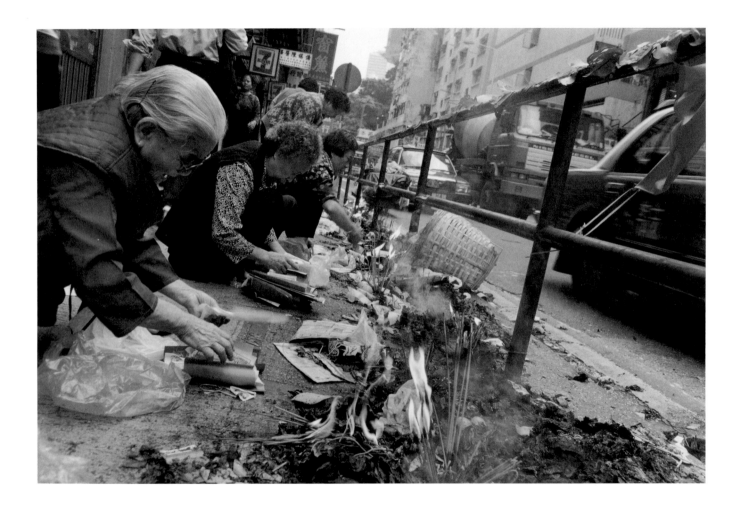

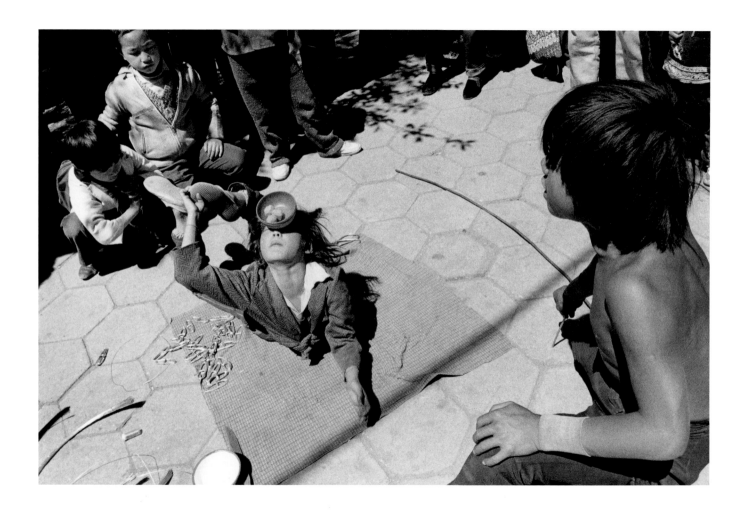

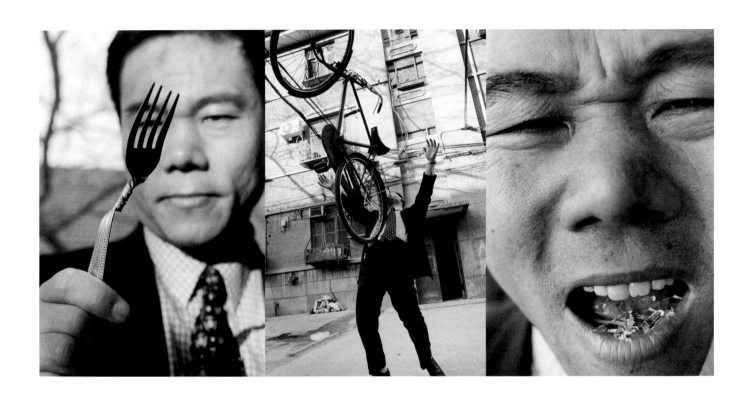

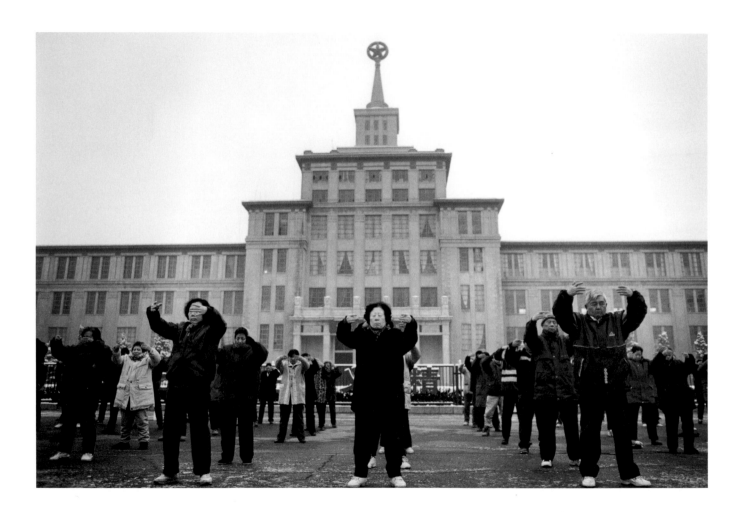

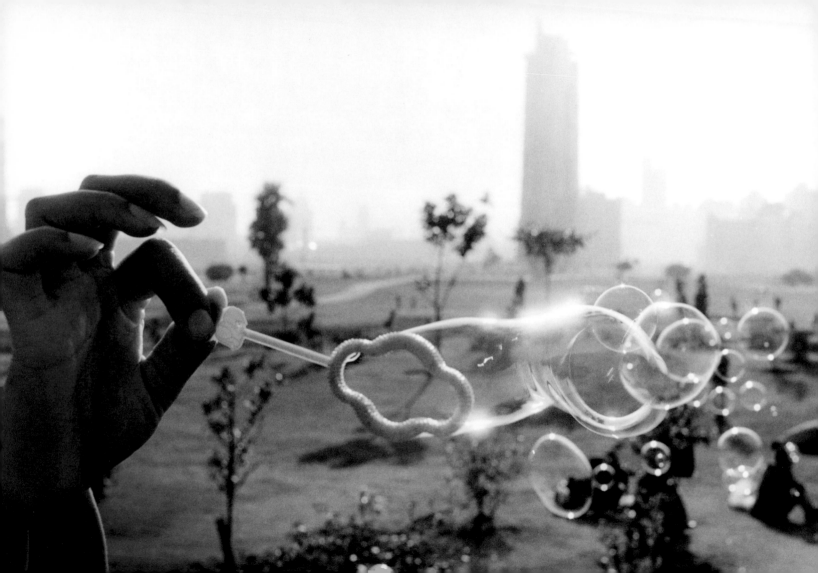

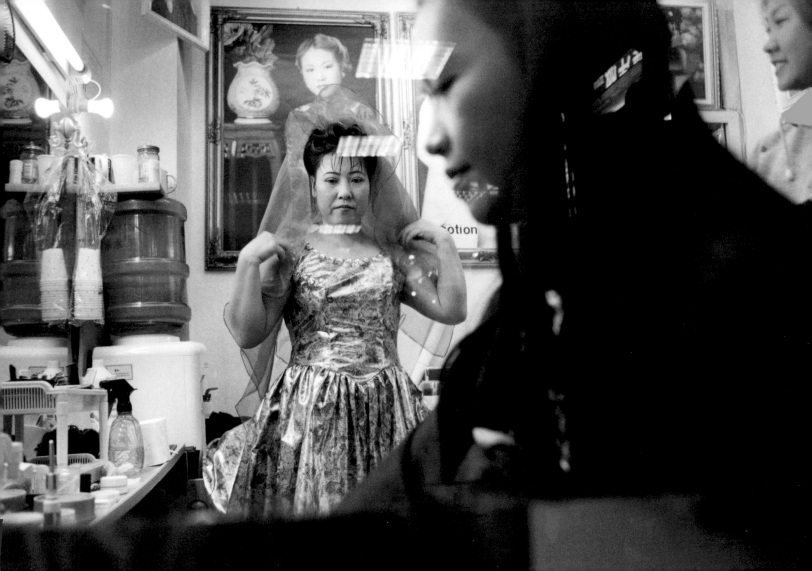

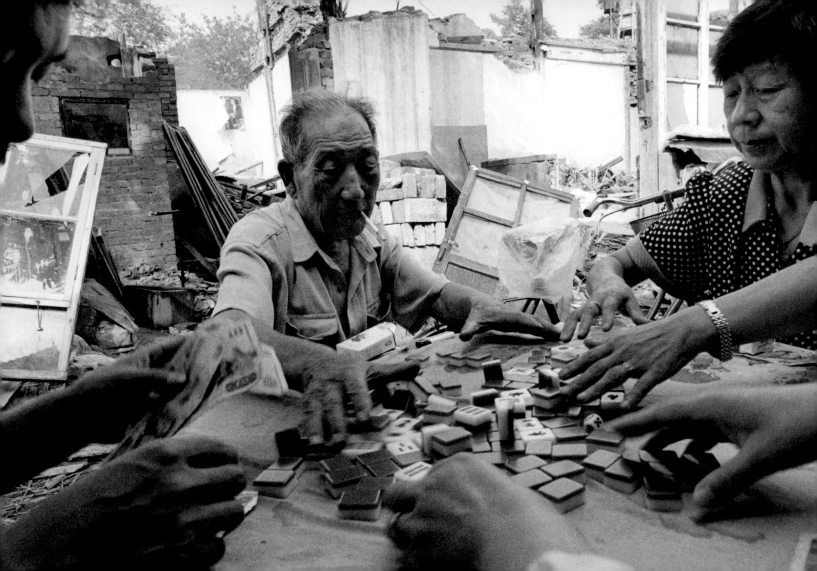

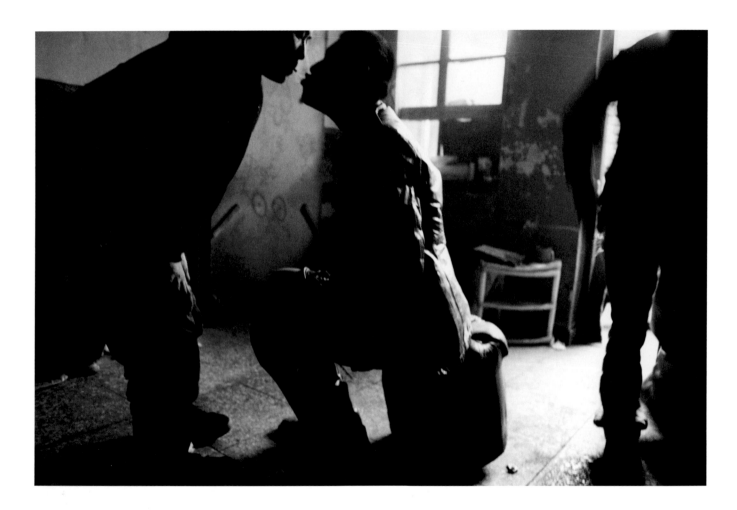

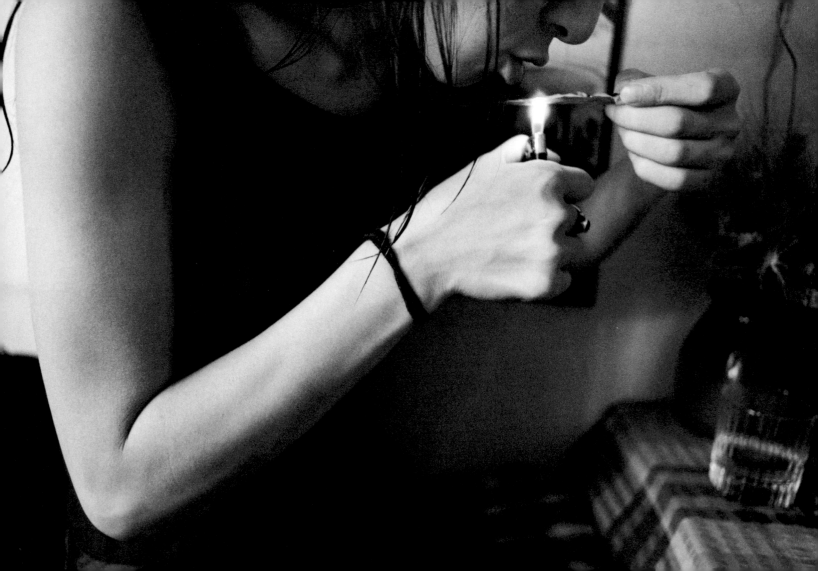

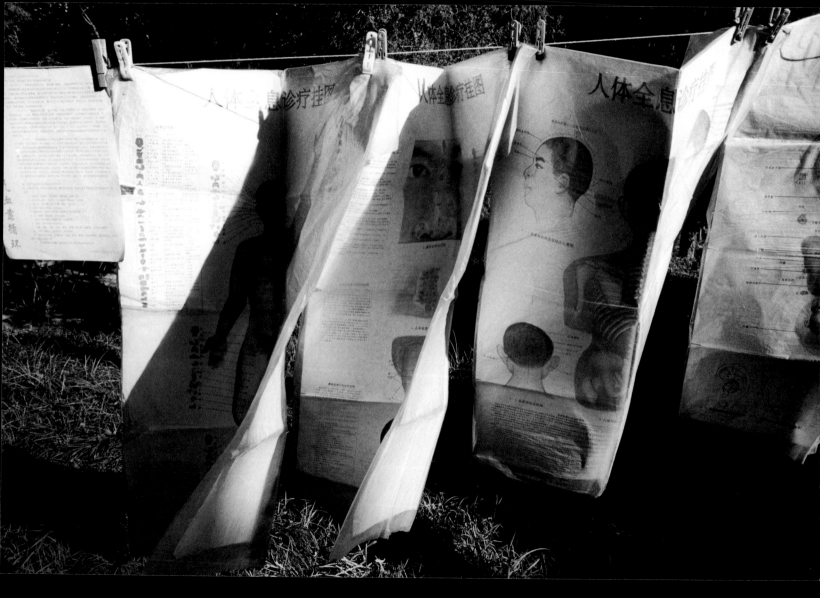

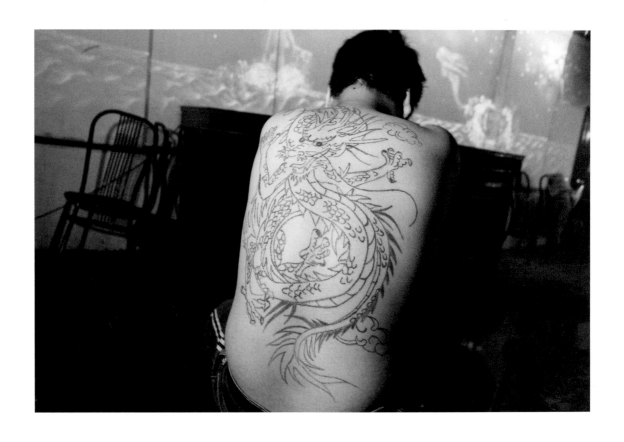

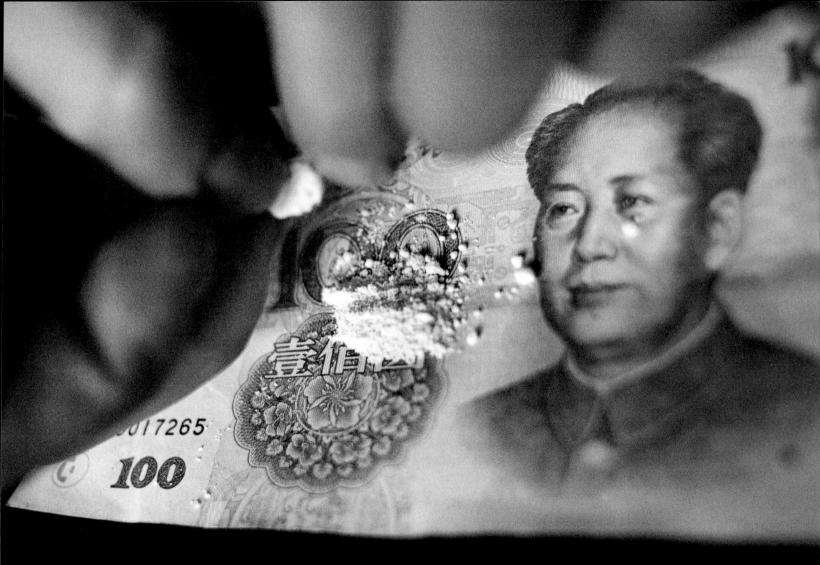

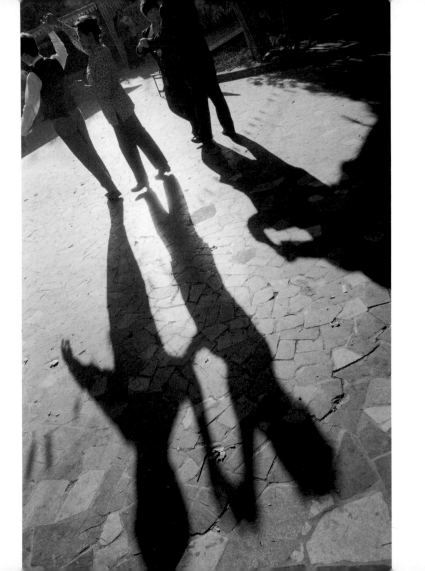

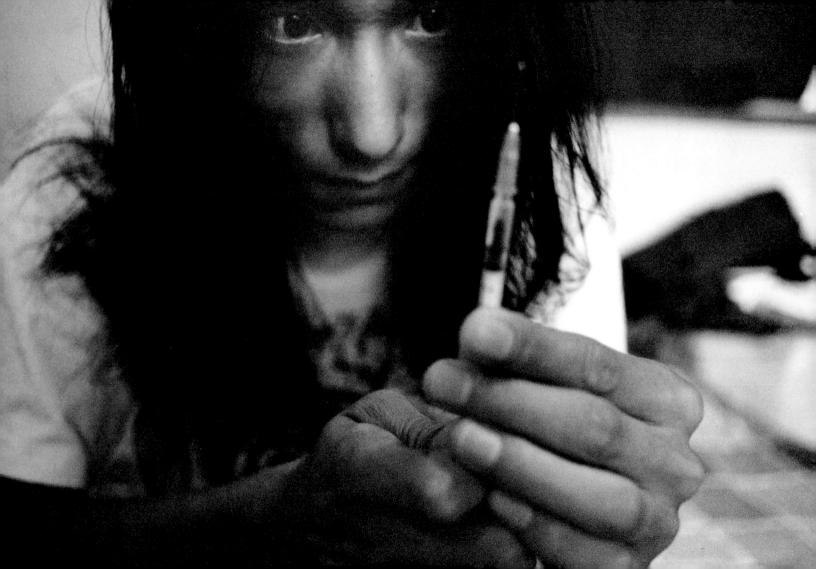

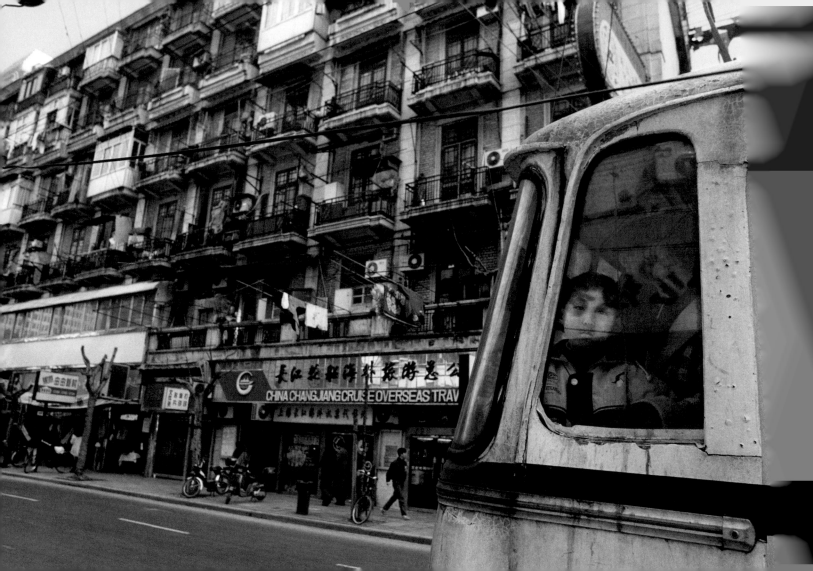

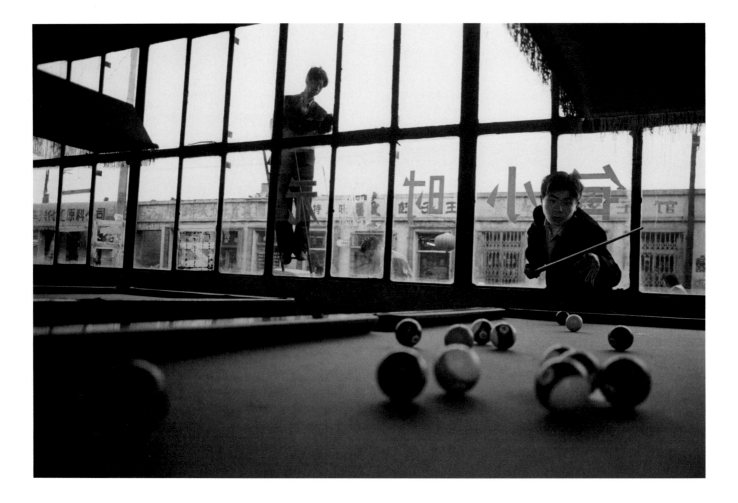

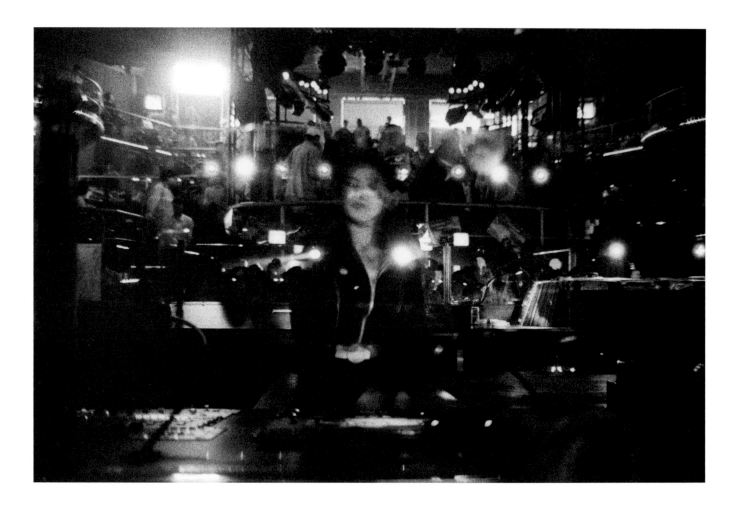

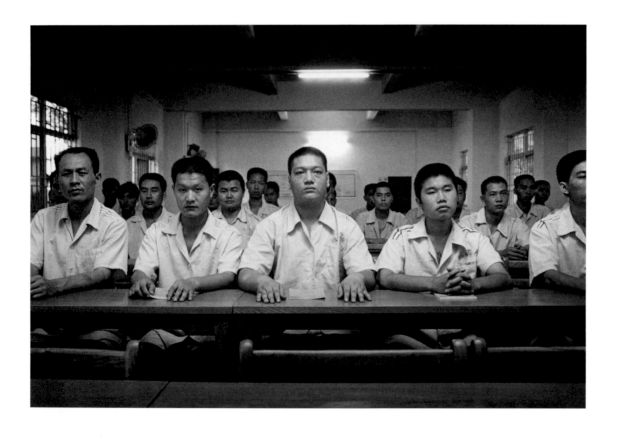

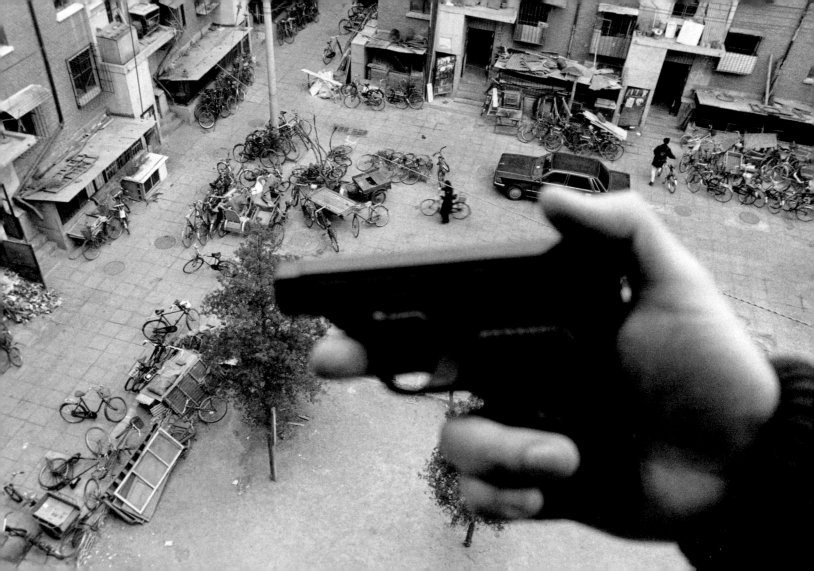

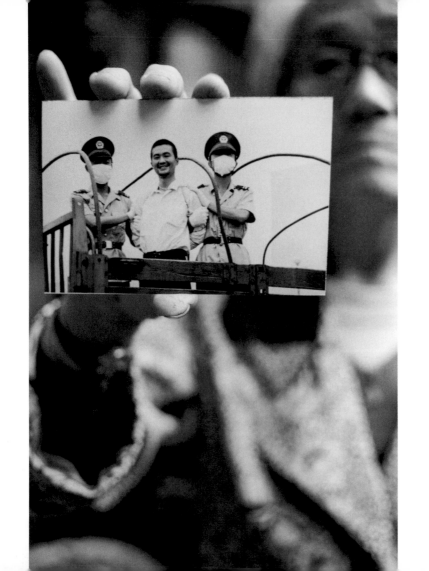

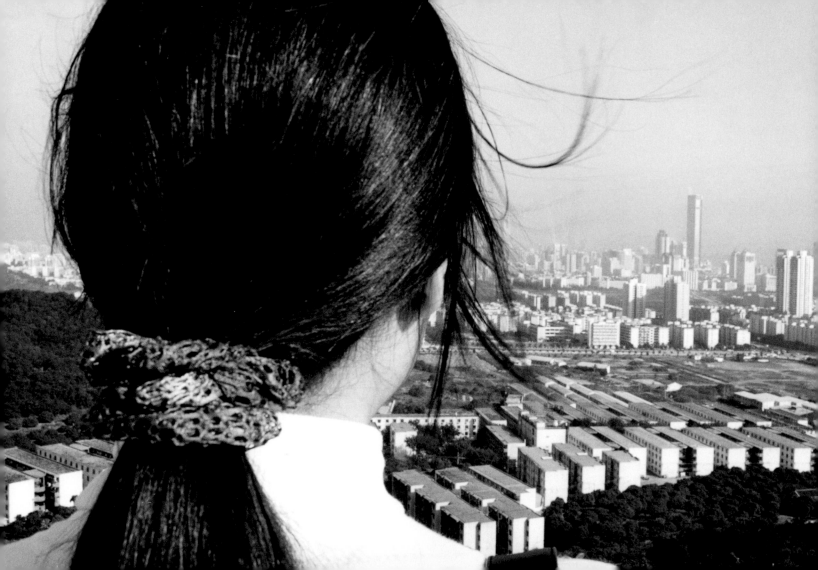

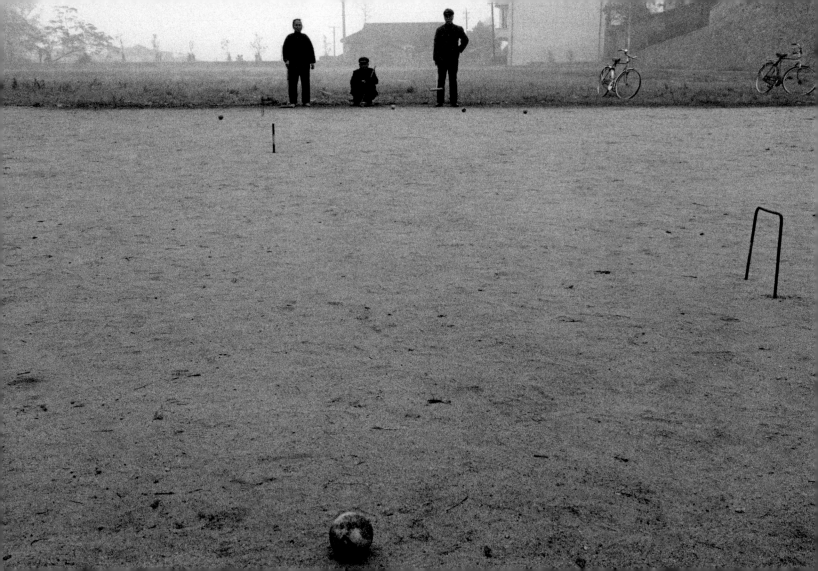

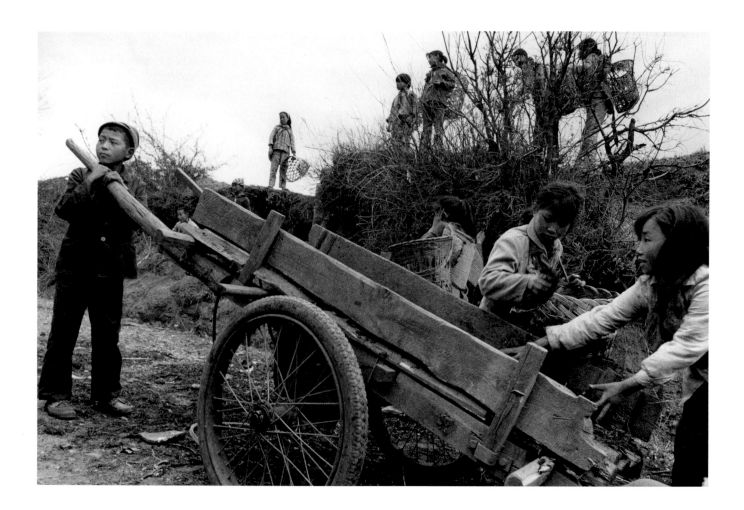

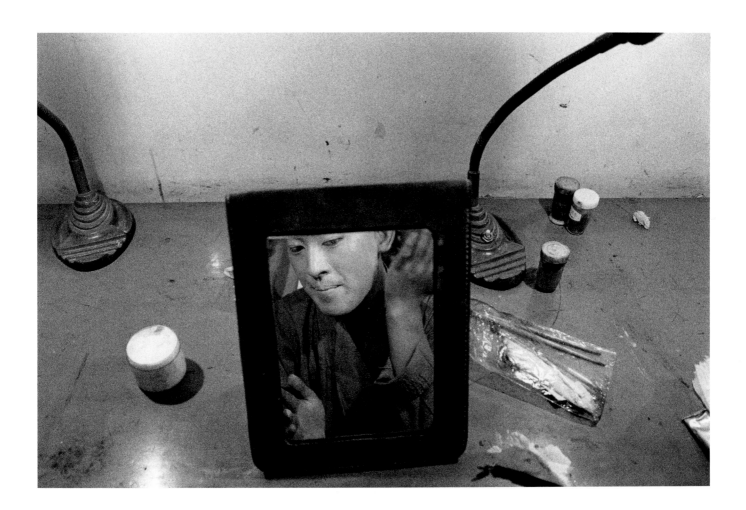

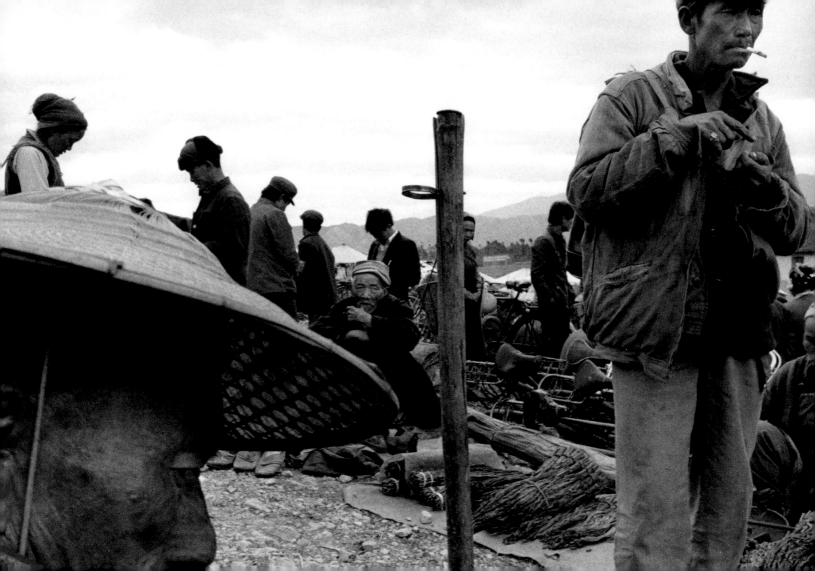

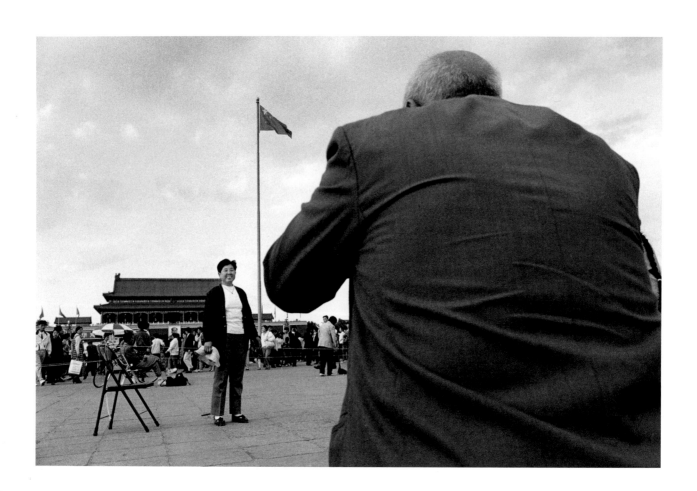

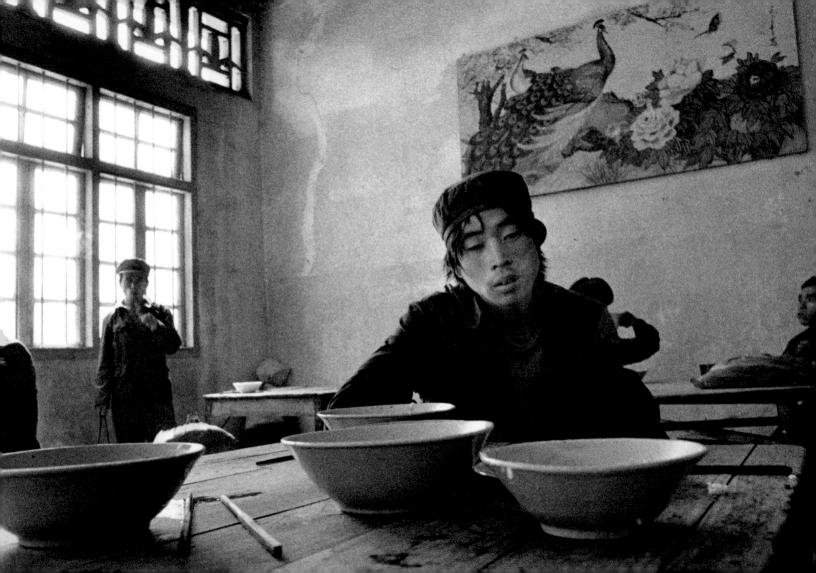

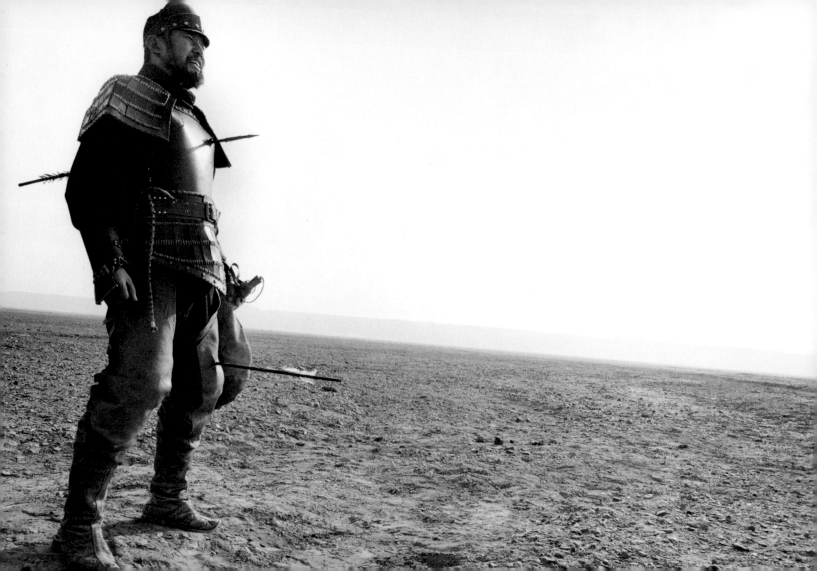

AFTERWORD: PETER HESSLER

I originally saw some of these scenes in color. There was movement as well, and even now, when I look at the images, they recall distinct narratives. In the writer's mind, there is always a story pressing against both sides of the photographic frame—a history and a postscript.

I met Mark Leong in 1999, after both of us had already lived in China for some time. We first worked together on a story in November of that year. The Communist government was cracking down on Falun Gong, an exercise and spiritual group that had organized a remarkable protest in Beijing that spring. For the rest of the year, dark rituals played out on Tiananmen Square: protestors waved banners; plainclothes cops tackled the believers and carted them away; foreign correspondents watched. We recorded the events, but nobody could make much sense of what was happening. Many incidents in China were like that.

On that day in November, Mark and I met with Sima Nan. For years, Sima had worked to debunk qigong charlatans—people who claimed that they gained special powers by practicing traditional Chinese meditative breathing exercises. Sima had been an early critic of Falun Gong, and now he found himself riding a wave of publicity in the wake of the crackdown. He owned a television production company—the videos featured Sima performing common *qigong* tricks—and he was busy. His cell phone rang constantly. His office was decorated with photographs of Marilyn Monroe and Mao Zedong; behind his desk were statues of René Descartes and Qin Shihuang, the first emperor to unify China. During our conversation, Sima mentioned that he had participated in the 1989 pro-democracy demonstrations on Tiananmen Square—after the massacre, he had lost his job as a journalist with the government-run *China Economic Times*. Like certain individuals in today's China, Sima was pragmatic and contradictory and completely lucid. He had received a national "Hero of Atheism" award, but he told me that Chinese society needs religious leaders, broadly defined.

"Mao was this type of person," Sima said. "Their work has to do with the heart and soul; they can solve the problems of an

empty heart. Whether it's Mohammed, or Jesus, or Buddha, or even Mao, they're all playing the same role."

After the interview, he performed for Mark—breaking a brick with his bare hand, bending a fork between thumb and forefinger. Camera in hand, Mark squatted low to the ground, rose up on his toes, swooped in close. Sima twirled a bicycle with his teeth. It became a strange sort of dance, the two men circling, each pulled by the gravity of his instrument: a man with a bike, a man with a camera.

The pull was strongest during the demonstration of glass-eating. Mark's lens was inches away from Sima's mouth—teeth, tongue, jagged shards—when the cult-buster's cell phone rang again. Without a word, he passed the handset to his assistant. "Hello?" the man said. "He's . . . he's a little busy right now. Can you call back?"

* * *

For any documentarian working in China during the past fifteen years, the most important skill was a sense of subtlety. Since the crackdown on the democracy movement in 1989, there have been no coups or major political struggles, and no charismatic leaders have risen to power. Press conferences were mostly useless; anniversaries fizzled out; even big protests turned out to be dead ends. There were limits to what you could learn in Beijing and Shanghai. The peripheries mattered—provinces like Guangxi and Zhejiang; cities like Shenyang and Shenzhen and Wanxian. A week in a village felt like a month in the capital.

Certainly, there were notable events: the death of Deng Xiaoping, the return of Hong Kong, the massive protests after NATO bombed the Chinese embassy in Belgrade. This was history, traditionally defined. But each of these incidents, like the suppression of Falun Gong, created an initial frenzy of activity and then slipped out of the national consciousness. The best photographs of these events feel localized, as if history has passed through a prism: an unfinished statue of a departed leader, a children's musical band practicing for a distant handover, an American flag rising above the epaulets of military police. An X-ray of a dead man's chest; a mouthful of glass. A customer at KFC—a lunch break in a month of anger.

The events didn't create a narrative, but people's lives did. For almost an entire century, important dates and priorities had been defined for them—May Fourth, June Fourth, October First; the People's Republic, the People's Liberation Army, the People's Political Consultative Conference. But now individuals created their own sense of time, making key decisions—to migrate or stay at home; to go into business or keep the work-unit job. They drove straight or they veered into the ditch. If you watched carefully, the details stayed with you: a key dangling from a drawer, a baby's foot next to an old woman's hand, a pile of exhausted travelers at a train station. Tea bottles waiting patiently in cubicles while workers made mice. Metal hearts next to metal stars, pinned to the iron gate of an empty factory.

* * *

After the interview with Sima Nan, Mark and I were heading home when we happened to see a crowd gathered on an empty lot beside Ping'an Avenue. Mark told the cabbie to pull over.

A red banner hung in the sky: "China Welfare Lottery." The lot was a kaleidoscope of luck—everywhere, people were buying brilliantly colored tickets, scratching off the backs, chattering, shouting, pushing. A sign listed prizes: one hundred and sixty cars, six hundred color televisions. An official told me that it was the last day of a five-day event; they hoped to raise over four million dollars for "the old, the handicapped, and the poor." Six hundred washing machines, eight thousand rice cookers, half a million instant-cash awards. I met a man who had bought fifty tickets and won twenty-five cents. Suddenly, a loudspeaker crackled: new grand-prize winner. "There's a foreign journalist here!" a man yelled; somebody else pushed me forward. The winner was already in the back seat of the prize car, and they hustled me in beside him. Two officials sat in front—we were going to the lottery headquarters. I saw Mark as we pulled away. "I'll stay," he said, and then we were gone.

A loudspeaker had been mounted on top of the car, and the official in the passenger's seat shouted into the microphone: "In the back we have a winner of the China Welfare Lottery! He just won this car—and there are still eight more left if you want to take the chance!" Traffic slowed; cab drivers honked and waved. Pedestrians stopped to stare.

It took me a moment to get my bearings. The first thing that registered was the car—bright purple, deep purple, plum purple, an Alto "City Baby" SC7080A. The retail value was about seven thousand dollars; my knees pressed against the subcompact's front seat. And the second thing I noticed was that the winner was completely calm.

His name was Fu Yuan, and he was in his mid-forties. Fu told me that he had purchased five hundred tickets, for a quarter each. When I asked if now he would take driving lessons, he told me that he already owned a Volkswagen Jetta and two minivans. Fu did business. Our impromptu parade seemed to embarrass him. When I asked if he felt lucky, he looked me in the eye. "It's not enough good luck to win," he said. "If you know how to take care of what you win, and how to use it well—that's good luck. That's what really matters."

Days later, I saw Mark's photograph: feet, legs; black shoes, black trousers; a carpet of tickets spread across packed dirt; singles, doubles, triples, strips of four, five, six; all of them scratched, bent, discarded, forgotten like so many shades of gray.

ACKNOWLEDGMENTS: MARK LEONG

ACKNOWLEDGMENTS: MARK LEONG

I would like to express my thanks and appreciation to:

Jack Lueders-Booth, my friend and mentor

The Fongs of Soon Wall Village and Chicago
The Leongs of Dai Dun Village and California
Jin Hua and the Central Academy of Fine Arts

Tinne Loh, Ian and Elke Johnson, Susan Ritchie, Patrick Li,
Ron Keren, John Cobau, Susan Meiselas, Gilles Peress, Robert
Gardner, Lisa Botos, Xie Tianxiao, Kristy Reichert, Andy Patrick,
Michael Bierut, Duncan Hewitt, Rania Ho and Wang Wei

Steve Mockus, Sara Schneider, and Tera Killip of Chronicle Books

Lisa Carmel and Peter Fairfield of Gamma Labs

The Fifty Crows International Fund for Documentary
 Photography
The National Endowment for the Arts
The Lila-Wallace Reader's Digest Foundation/Arts International
The George Peabody Gardner Fellowship Program
The Carpenter Center for the Visual Arts at Harvard University

and most of all, Sharon—my home is wherever you are.

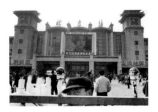

BEIJING, 1997
Train station.

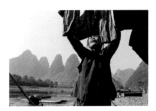

GUANGXI, 1989

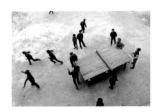

GUANGXI, 1989
Table tennis.

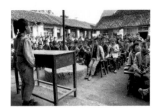

YANGSHUO, 1989
Elementary student recites sayings from
Chairman Mao at a school assembly.

SICHUAN, 1993
Passengers in a sleeper compartment
watch workers boarding their train's
cheaper "hard-seat" cars at a small-
town station.

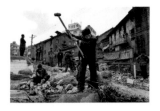

CHONGQING, 1993
Workers level off a city block.

SHANGHAI, 1993

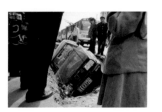

SHENYANG, 1998
Car-jacking aftermath. In broad daylight, a
group of thugs jumps in a taxi, holds a knife
on the driver, and tells him to drive out of
town. The driver, fearing for his life, deliber-
ately steers into a ditch. This risky strategy
pays off: he escapes unscathed, and the
thieves are captured.

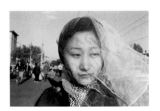

SHENYANG, 1998

A woman wears a veil to keep coal dust out of her face in one of the world's most polluted cities.

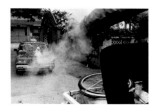

GUANGDONG, 1990

Carrying furnishings for the newlyweds' new home in a truck, the couple's friends precede the bridal car, exploding firecrackers to dispel any evil lurking nearby.

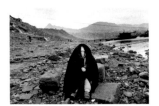

WANXIAN, 1993

A child stays warm beneath her mother's coat while waiting for her to do laundry on the banks of the Yangtze River in the Three Gorges area.

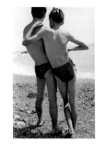

DALIAN, 1989

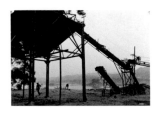

GUANGXI, 1989

A machine loads sand for making cement.

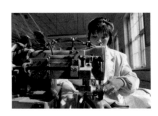

BEIJING, 1992

Garment worker sews clothes destined for the Japanese market.

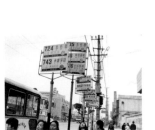

BEIJING, 1997

Bus stop.

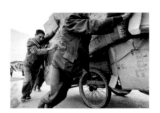

FULING, 2000
Porters push a cart of shoes up from the docks to the market.

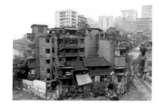

FULING, 2003
A sign in a neighborhood near the river marks the 177-meter mark, the projected level of the water after the third and final phase of the Three Gorges Dam is completed.

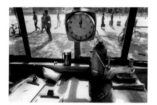

BEIJING, 1993
Traffic monitoring office.

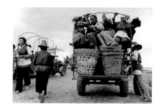

DALI, 1990
Bai minority women return from the weekend market.

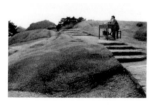

ANHUI, 1989
A photographer waits by the side of the path to take souvenir photos of visitors hiking up the scenic mountain Huangshan.

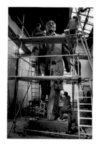

BEIJING, 1997
Barely five feet tall when he was alive, Deng Xiaoping now towers two stories high as a likeness of China's late leader rises in Beijing the week following his death on February 19. The final version stands in the southern coastal city of Shenzhen, allowing Deng to observe the return of Hong Kong to China on July 1.

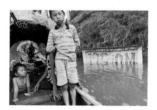

WUSHAN, 2003
The Yangtze River begins rising as the Three Gorges Dam starts operation after a decade of construction. The water level tops the 125-meter target markers June 10, ten days after the sluice gate was closed for the first time.

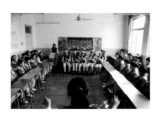

BEIJING, 1997

At the Hongmiao Elementary School, students take part in a special classroom activity about the return of Hong Kong to China from British control. The blackboard reads "Hong Kong, the Motherland Welcomes You." Following a patriotic song, a student reads a letter to his cross-border counterparts: "After a century of hard times, Hong Kong will finally return to the Motherland's embrace. Do you know about the Motherland? Led by President Jiang Zemin, it is developing rapidly. Unfortunately, our dear Grandpa Deng Xiaoping passed away before he could see the handover."

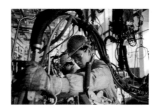

NANCHANG, 1997

Ford Transit joint-venture minibus plant.

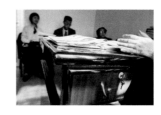

BEIJING, 1997

Reporters meet with Professor Wang Xuan, the Chinese-language laser typesetting pioneer who became chairman of Peking University's high-technology products group, Founder Holdings, Ltd.

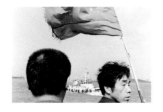

SHANGHAI, 2000

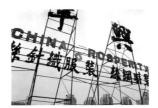

SHENZHEN, 2000

Clothing factory sign.

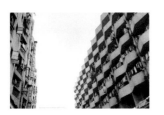

SHENZHEN, 2000

China's economic progress is fueled by cheap labor from the countryside, with workers stacked by the thousands in factory compound dormitories.

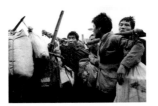

GUANGZHOU, 1990

Migrant workers crowd the train station, trying to get home for the Lunar New Year holiday.

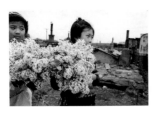

SHENYANG, 1998

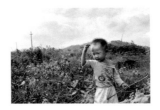

GUANGZHOU, 1989

GUANGZHOU, 1989
Workers nap after lunch.

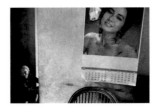

GUANGDONG, 1989

GUANGXI, 1989
Public toilet.

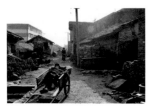

GUANGXI, 1989
Elderly man waits for his son to bring him
to the doctor.

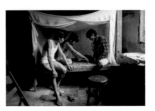

GUANGZHOU, 1989
Middle school students play Chinese chess
in their dorm.

SHUNDE, 1990

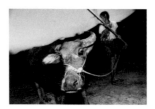

TAISHAN, 1994
Villagers show me a cow that my uncle Louie, who moved to Chicago in the 1930s, sent money back for the family to buy.

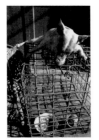

TAISHAN, 1995
Tradition says that eating dog meat increases the body's internal heat, keeping one warm in the winter.

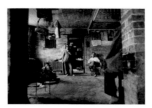

TAISHAN, 1995
The village chief sits in the house my grandfather left behind in the 1920s, waiting to give me a letter to show to relatives and former villagers in America, asking for donations to pave the way from the village to the main road.

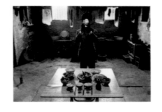

TAISHAN, 1990
Ancestor worship ritual during the Lunar New Year, with food offerings and symbolic paper money burnt to send to the spirit world.

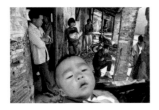

TAISHAN, 1995
My mother's ancestral village of Soon Wall has shrunk from 350 people to 120 in five years, with residents leaving for the new urban industrial centers or emigrating to America.

CHICAGO, 1995
My grandmother's ID photo for immigration to America, along with a crib sheet to help her remember the details of the false identity she purchased from a neighbor.

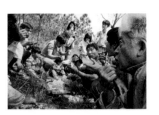

TAISHAN, 1995
The Gravesweeping Festival as celebrated in the Guangdong countryside involves suckling pig offerings, firecrackers, hoes to sweep the weeds off the tombs, and feasts on the gravesites.

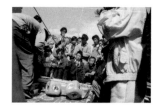

DALI, 1999
Gamblers bet on big dice marked with animals.

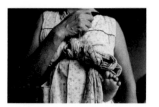

TAISHAN, 1995
According to its remaining residents, my mother's ancestral home of Soon Wall has become "a village of old people and babies," since most of the young people have left for big Chinese cities, Hong Kong, and North America.

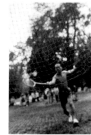

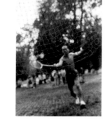

BEIJING, 1997
Early morning badminton.

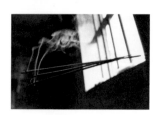

TAISHAN, 1995
Burning incense communicates to my ancestors that I have returned to my grandfather's house.

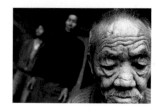

TAISHAN, 1995
Fong Ny Geung, at eighty-three, my oldest living relative in China.

DALIAN, 1989
State-run beauty salon.

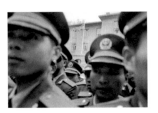

BEIJING, 1999
Policemen form a human barricade in front of the U.S. Embassy, blocking demonstrators protesting the NATO missile attack on the Chinese Embassy in Belgrade.

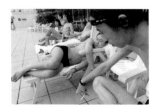

BEIJING, 1998
Slackers wait by a hotel pool, hoping to meet foreign women.

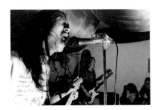

BEIJING, 1997
Xie Tianxiao, twenty-five, came to Beijing from Shandong Province six years ago to dive into the capital's underground music scene. He sings, plays guitar, and writes the songs for the slacker rock band Cold Blooded Animal.

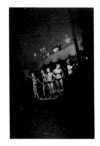

ZHEJIANG, 1997
Tent strip show.

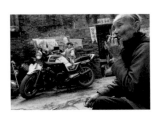

SHUNDE, 1990

BEIJING, 1994
Duan-duan, a nineteen-year-old aspiring model and actress, hangs out at her friend's place, looking at Western magazines and listening to Western music.

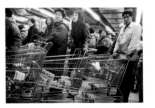

BEIJING, 1996
Shoppers at Carrefour, the French supermarket chain.

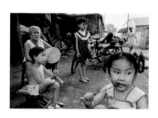

BEIJING, 1994

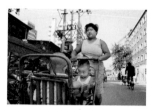

BEIJING, 1992
Twins.

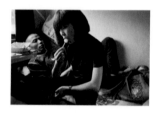

KUNMING, 1998
Couple on a rail journey.

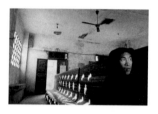

GUANGXI, 1989
Bus station.

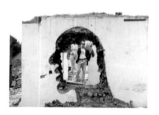

BEIJING, 1999
Urban deconstructionist AK-47, known for his graffiti heads sprayed all over Beijing, also makes his mark in 3-D in the capital's demolished neighborhoods, a comment on the wholesale destruction of Beijing's traditional homes and buildings.

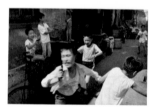

SHANGHAI, 1989

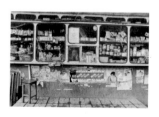

SHENYANG, 1998
Neighborhood store.

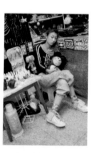

BEIJING, 2003
Sandy, twenty-five, sells body piercings, stuffed toys, and other gifts at her shop.

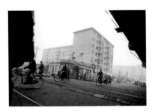

SHENYANG, 1998
Rail crossing.

SHENYANG, 1998

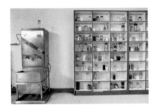

SUZHOU, 2001
The tea-break room at one of Logitech's computer mouse manufacturing plants.

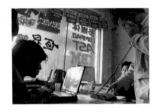

BEIJING, 1997
Laptop computer shop in the Zhongguancun high-technology district.

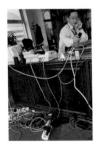

BEIJING, 2001
Edward Tian, CEO of China Netcom, is one of many who have returned to China to build a technological infrastructure after study and work in the United States.

GUANGDONG, 2000
Rat meat at a restaurant specializing in rat dishes.

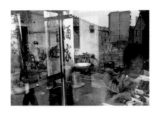

GUANGXI, 1989
Restaurant reflection.

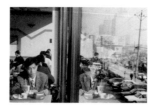

BEIJING, 1999
During the months of intense anti-American sentiment and angry demonstrations against the U.S. Embassy following the NATO bombing of the Chinese Embassy in Belgrade, young Chinese continued flocking to fast-food outlets like KFC and McDonald's.

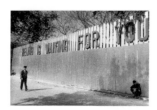

BEIJING, 1994
Slogan from the unsuccessful campaign to host the 2000 Olympics.

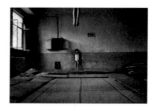

BEIJING, 2000
At the select Shichahai Sports School, young gymnasts aspire to become Olympic athletes.

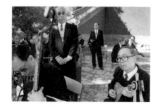

BEIJING, 1999
A traditional music ensemble prepares to perform at a concert celebrating the fiftieth anniversary of the founding of the People's Republic of China.

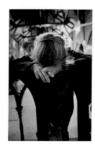

NANJING, 1998
Worshiper at St. Paul's Church.

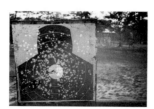

GUANGZHOU, 1989
Target used by college students in freshman military training.

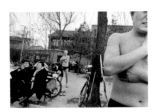

BEIJING, 1997
Winter swimmers.

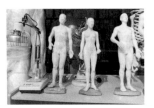

BEIJING, 2001
A medical supply store displays acupuncture dolls mapped with meridians and pressure points.

SICHUAN, 1998
Graffiti.

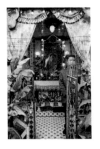

FULING, 2000
Shrine at a Catholic church.

GUANGXI, 2001
A series of mining disasters has led the government to crack down on small private mines, but many village coal holes remain open and active.

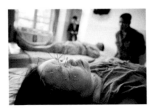

BEIJING, 1997
A woman receives acupuncture for facial paralysis.

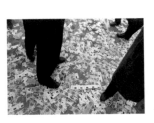

BEIJING, 1998
Losers of the Beijing Welfare Lottery.

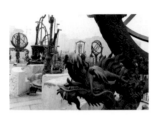

BEIJING, 2002
At the Ancient Observatory, various armillary spheres, quadrants, and other instruments used by astronomers to make celestial measurements during the Ming and Qing dynasties.

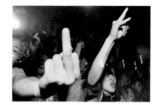

BEIJING, 2000
Rock fans show their support for the rap-metal stylings of the band Yaksa.

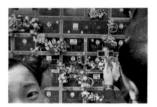

BEIJING, 2003
At the Babaoshan Revolutionary Cemetery, visitors pay their respects to the dead during the springtime Gravesweeping Festival by cleaning their memorial plaques and decorating them with flowers.

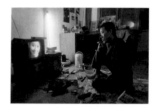

BEIJING, 1997
Video artist Zhao Liang, twenty-six, screens one of his short films.

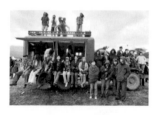

LIJIANG, 2002
Music fans gather at the Snow Mountain Music Festival, China's first major outdoor Woodstock-type rock concert.

NANJING, 2000
Ancient city wall.

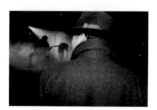

BEIJING, 1992
Plainclothes policeman monitors a show by the metal band Tang Dynasty.

QINGDAO, 2000

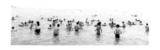

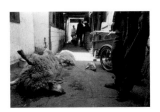

BEIJING, 1996
Chinese Uighur Muslims sacrificing sheep to observe Korban Bairam, a Muslim holy day of sacrifice.

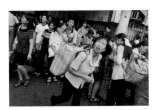

GUANGZHOU, 1998
Young women from Sichuan Province arrive at the train station in Guangzhou, where they hope to find factory work. These rural women are easy targets for kidnappers, who offer them jobs only to take them to some remote area and auction them off to farmers looking for second wives or for sex slaves.

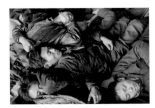

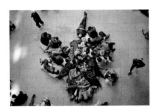

BEIJING, 1992
Migrant workers, who float from city to city looking for work, sleep in the train station until they can find jobs, usually on construction sites.

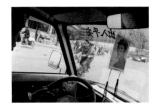

SHAANXI, 1993
Although various stories about the origin of the Mao picture as a protective talisman for drivers circulate, each involves a horrible crash in which the only survivor was the person sitting near a likeness of the Chairman.

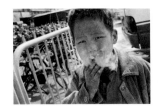

XIAN, 2000
A ten-year-old runaway from Gansu Province lives on a staircase near Xian Station, scrounging for food, smoking cigarette butts, and begging in order to survive. He left home over a year ago, saying, "My parents don't want me anymore."

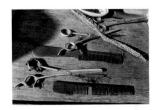

BEIJING, 1997
Tools of a streetside barber.

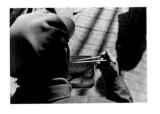

BEIJING, 1994
Cabbage seller's lunch.

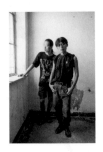

BEIJING, 1998
Students come from all over China to learn to rock at the Midi Music School.

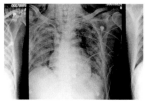

BEIJING, 2003
Chest X-ray of a 41-year-old doctor of traditional Chinese medicine who had just died of SARS. Hospital personnel say though his case was serious, he was in good spirits and they had high hopes for his recovery until the elderly woman in the bed beside his in the quarantine ward expired. After that, his condition deteriorated rapidly.

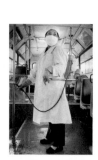

LIJIANG, 1990
Dentist office.

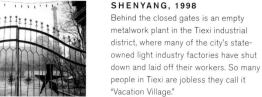

SHENYANG, 1998
Behind the closed gates is an empty metalwork plant in the Tiexi industrial district, where many of the city's state-owned light industry factories have shut down and laid off their workers. So many people in Tiexi are jobless they call it "Vacation Village."

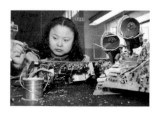

SICHUAN, 1994
Established in 1958, Changhong Electronics produced radar equipment as part of the so-called Third Line of military factories located in China's mountainous interior to defend against attacks by the Soviet Union or the United States. It is now the world's fourth largest producer of television sets.

BEIJING, 2003
During the SARS scare, city transportation employees use hydroacetic acid to disinfect buses at the end of every route.

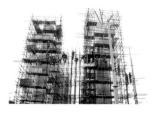

SHANGHAI, 1997

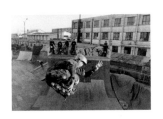

BEIJING, 1999
A businessman with no knowledge of Rollerblading brought a bunch of young martial arts students from the provinces to Beijing to live in a skate park, gave them equipment and videos of Western bladers, and told them to practice every day, with the idea of developing an exhibition team for promotional events.

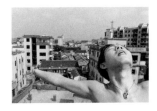

SHENZHEN, 2001
Dang Jianjun, twenty-one, lost both arms in a factory punch press accident on August 13, 1999, at 2:00 A.M., eight hours into the overnight shift. Thirty-one such accidents a day happened that year in Shenzhen. Dang came to Guangdong's industrial zone from Xian when he was sixteen. He is suing the Taiwanese-owned company for compensation.

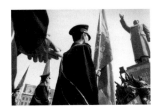

SHENYANG, 1998
Initiation ceremony for new traffic patrol members.

BEIJING, 1996
Many of the capital's old alleyway neighborhoods are being leveled to make room for new development.

BEIJING, 1993
Advertisement for goggles that vibrate to stimulate the eyes and improve vision.

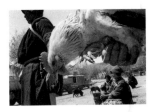

LIJIANG, 1990
Naxi minority women.

BEIJING, 1996
Brand recognition campaign by the microprocessor company.

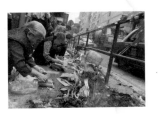

HONG KONG, 1999
A group of women are hired to perform a ritual of apology involving incense, food offerings, and the burning of paper tigers.

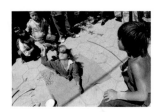

DALI, 1990
Street performers.

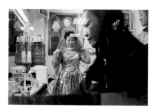

SHENZHEN, 1999
A young woman tries on a rented wedding dress at a photo studio. She is already married, but only now has she saved up enough money to have pictures taken.

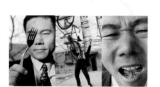

BEIJING, 1999
"Cultbuster" Sima Nan bends a fork with his "mind," picks up bicycles with his teeth, and swallows shards of broken glass to show that the demonstrations so-called spiritual leaders give to prove their powers are nothing more than simple tricks that anyone can do with a little practice.

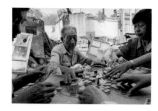

BEIJING, 1996
Neighbors play mah-jongg while their houses are demolished all around them.

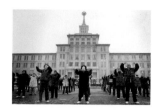

BEIJING, 1998
Groups of Falun Gong followers numbering in the hundreds and sometimes thousands practiced spiritual breathing exercises openly before the government cracked down on the movement in spring 1999.

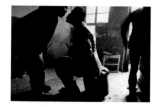

BEIJING, 1998
A punk blows hash smoke into his friend's mouth.

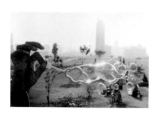

SHENZHEN, 2000

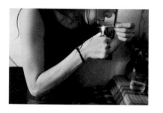

BEIJING, 2001
A twenty-six-year-old heroin addict "chases the dragon," inhaling the vapors of powder heated from beneath a slip of cigarette-box foil. She rarely goes out of her mother's work unit apartment, where she and her boyfriend live.

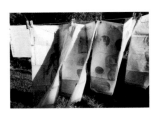

BEIJING, 2000
Charts showing acupuncture points and other traditional Chinese medical information hang in the park for public perusal.

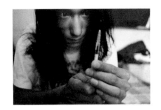

BEIJING, 2001
A twenty-eight-year-old heroin addict continues his six-year-old habit. He usually smokes the drug, but his supply is running low, and injecting ensures that he won't waste any.

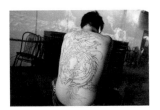

BEIJING, 1999
Bao Bao, twenty-two, wears a tattoo he had done in prison while serving eight months for beating somebody up.

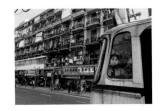

SHANGHAI, 1998
Public bus.

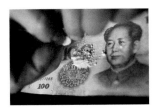

LANZHOU, 2002
A user breaks small paper pods of heroin on a crisp 100 yuan note, where he sifts it before smoking it. It is important to use a brand-new bill so that the powder won't stick or get caught in the folds.

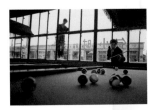

SHENYANG, 1998

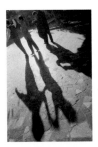

BEIJING, 1997
Morning ballroom dancing in the park.

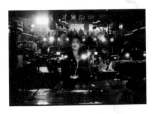

BEIJING, 1996
Disco.

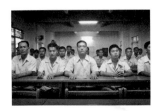

DONGGUAN, 2001
Inmates at the Dongguan City Drug Treatment Institute attend ethics class, where they are lectured on such moral dilemmas as: "If you are in a shop and see something you want and nobody is watching, what do you do?" Other rehab methods include taking herbal medicine, singing patriotic songs, reading anti-drug pro-Party literature, and performing manual labor. There is a high level of relapse among inmates.

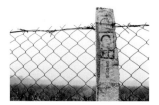

BEIJING, 2002
Fence around the land set aside for the future China Airspace Research Center.

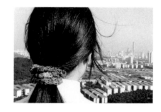

SHENZHEN, 2000
View from Lotus Hill Park. Shenzhen was a township of rice paddies and fish ponds just over the border from Hong Kong. It quickly developed into an industrial metropolis following its designation as a Special Economic Zone in 1980, as Deng Xiaoping began to experiment with an internationalized market economy.

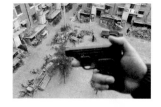

BEIJING, 1994
Mr. Ji, a twenty-six-year-old who manages an unregistered stock speculation business, bought a gun on the black market to protect himself when carrying large amounts of cash.

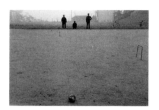

GUANGXI, 1989
Croquet.

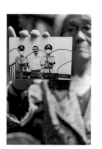

HENAN, 2002
A woman holds a snapshot of her son taken just before he was executed by a gunshot to the head. He had hired a relative to murder his wife when he suspected her of having an affair. He is smiling, she says, because he is glad to be dying, hoping to be reunited with his wife in the happier circumstances of the afterlife.

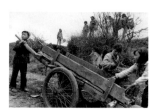

LIJIANG, 1990
Elementary students help clear the fields during class time as their labor contribution to the community.

BEIJING, 1992
Student studying Beijing Opera puts on makeup.

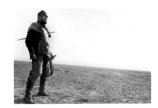

XINJIANG, 2001
Actor Harrison Liu is "shot to death" in the Tang Dynasty–period adventure film *Warriors of Heaven and Earth*.

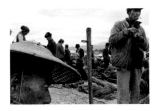

DALI, 1990
Tobacco market.

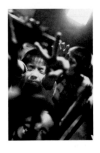

TAISHAN, 2002.

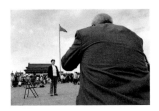

BEIJING, 1995
Visitors to Tiananmen Square for National Day (October 1).

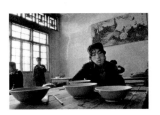

GUANGXI, 1989

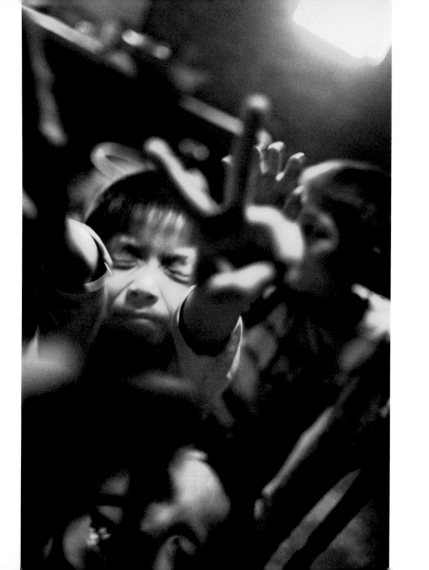